WARMINSTER

THROUGH TIME

Andrew Pickering
& Kathryn Dyer

AMBERLEY PUBLISHING

Secure the Shadow 'ere the Substance Fades.

Frederick Futcher, proprietor in 1899 of a photography shop at 36, High Street, Warminster.

First published 2013

Amberley Publishing
The Hill, Stroud
Gloucestershire, GL5 4EP

www.amberley-books.com

Copyright © Andrew Pickering & Kathryn Dyer, 2013

The right of Andrew Pickering & Kathryn Dyer
to be identified as the Author of this work
has been asserted in accordance with the
Copyrights, Designs and Patents Act 1988.

ISBN 978 1 4456 1058 0

British Library Cataloguing in Publication Data.
A catalogue record for this book is available from
the British Library.

Typeset in 9.5pt on 12pt Celeste.
Typesetting by Amberley Publishing.
Printed in the UK.

Introduction

Most of the older photographs in this book depict Warminster as it appeared in the early decades of the twentieth century. Nearly all have been donated for this project by the town's Dewey Museum, which should be commended for its generosity and vision in permitting these precious images to enter the public domain through paper publications and electronic media. Many have appeared in books before, and a collection of forty can be found on the BBC Local History website. The *Through Time* series of books provides a new perspective on such collections by juxtaposing the older images with recent ones and, in so doing, creates a historical record of our own time for future generations.

The picture of Warminster portrayed by these early photographs is one of a bustling town, its eighteenth- and nineteenth-century prosperity evident in a very wide range of fine civic, commercial, communal and private properties. Photographed and printed, for the most part, as souvenir postcards, the less salubrious quarters of the town are poorly represented, and the grinding poverty endured by part of the town's population, particularly in the depressed inter-war period, is hidden from view.

Warminster's industrial and agricultural heyday had already passed by the dawn of the age of the picture postcard. Its once important role in the Wiltshire woollen cloth industry was a distant memory; its famous corn market was much reduced and a mere two malthouses operated in the town by the end of the nineteenth century where once there had been twenty-five – its population had been steadily declining over the last five decades. The absence of any great revival in Warminster's economic fortunes during the twentieth century is evident in the paired images in this book, which show, for better or worse, how little the architectural fabric of the town, as it looked a century ago, has changed. However,

the town has not ceased to develop in other respects – most significantly perhaps, it has acquired a military association, due to its proximity to the Battlesbury Barracks and the Salisbury Plain training grounds. Although it never became the holiday resort that ambitious town councillors envisaged at the start of the twentieth century, it has nevertheless benefited from the commercialisation of the neighbouring Longleat estate and the Centre Parcs holiday village.

The town attracted tourists of another kind – UFO spotters – in the 1960s and 1970s when it became the focus of a number of alleged sightings, now debunked by experts as hoaxes or the creation of lively imaginations. The foremost addition to the town's civic amenities in the last century was the town park, laid out in the early 1900s, which, ever since, has been a favourite playground for children and adults living in the town. The town has expanded considerably in recent times with the construction of housing and business estates. Its population, which had shrunk to 5,547 at the time of the 1901 Census, has grown to around 19,000. Some of Warminster's older commercial activities have survived, including malting. Warminster Maltings Ltd, situated at the premises built in 1879 on the site of a malthouse with eighteenth-century malting origins, is the oldest working example of its kind in Britain. The railway continues to play a very important part in the town's life and it serves as the principal station for commuters from miles around.

The images in this book have been arranged in a roughly geographical order, from east to west, and space has been found to include pictures of a few places of interest close to Warminster.

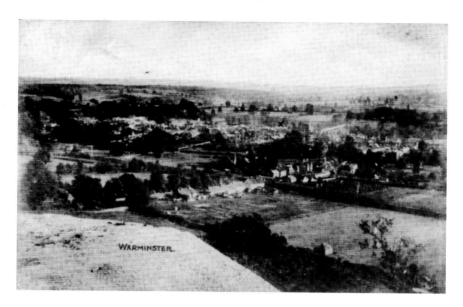

View of Warminster from Copheap

Copheap rises to the north of the town and offers excellent views in all directions from its summit. When the earlier picture was taken, open farmland still filled the space between the hill and the railway line. In more recent times developments, both residential and commercial, have filled it in. The photographs that follow reveal some of those changes in greater detail and demonstrate the endurance of Warminster's historic architectural landscape.

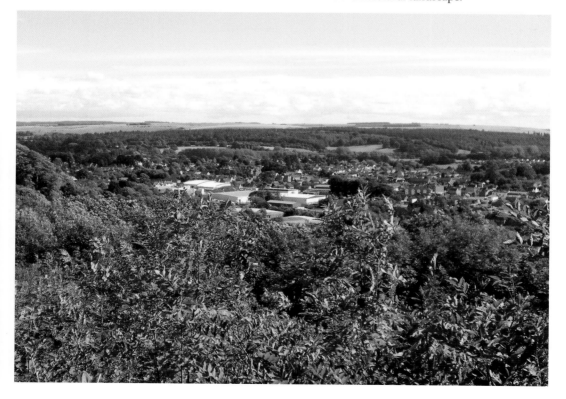

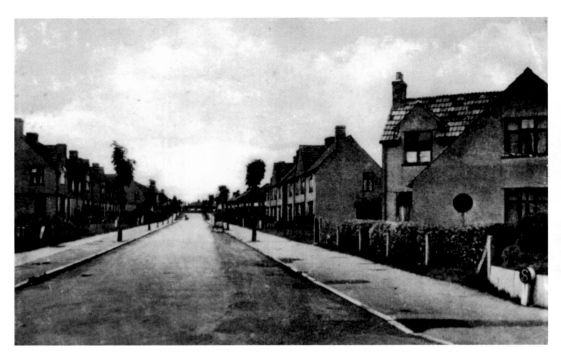

West Parade
In 1919 the Housing Act began to address the need for state-funded social housing developments. By 1921 the first six of forty-four new council houses, the first in Warminster, had been built on West Parade. West Parade connects to Pound Street to the south-east of the town centre.

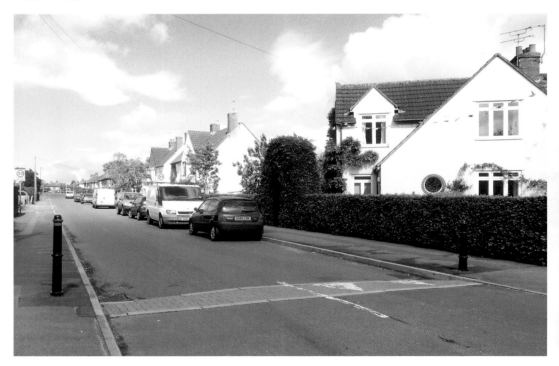

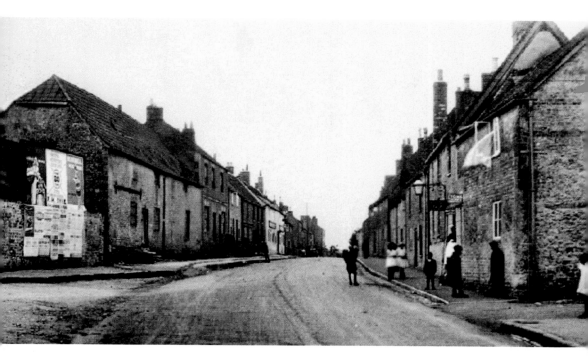

Pound Street & West Street Junction
The west end of the town was once home to several malthouses situated along Pound Street and Church Street. Just one of these, Warminster Maltings, remains in business. It was established in the eighteenth century and its premises on Pound Street were rebuilt in 1879.

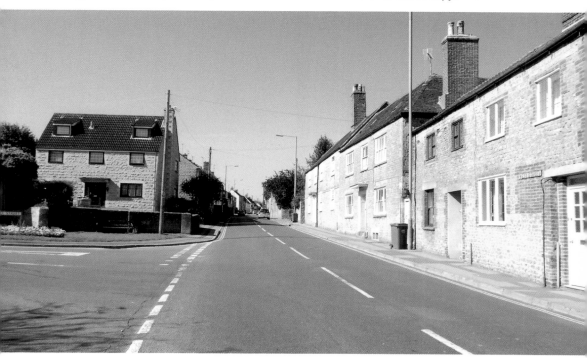

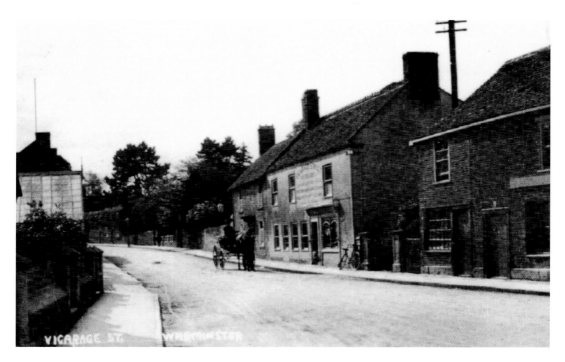

Vicarage Street

The older photograph of Vicarage Street, taken from the pavement outside the Minster School, dates from 1907. Vicarage Street remains home to the Sisters of St Denys' College, which was founded by the influential Vicar of Warminster from 1859 to 1897, Sir James Erasmus Philipps, for the training of missionaries. The St Denys' Convent buildings were purchased by Warminster School in 1994.

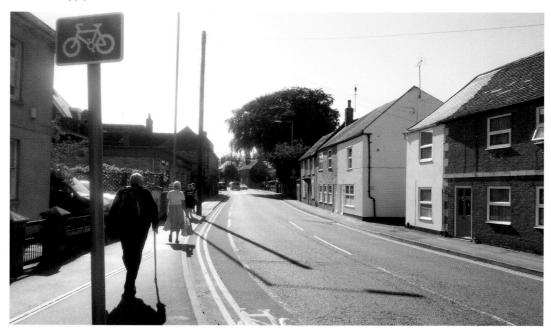

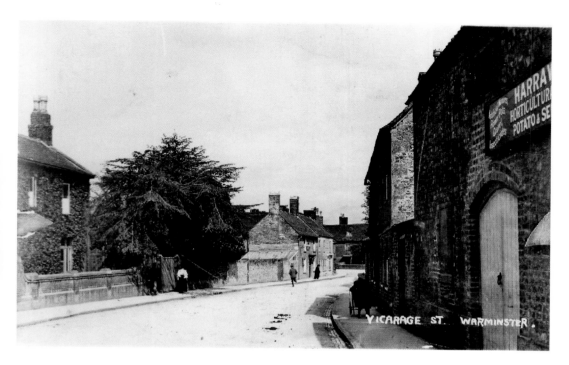

Harraways, Vicarage Street

Former business partners, Harraway and Scott were important nurserymen in nineteenth-century Warminster. Henry Scott ran a nursery on Boreham Road, and Thomas Harraway was based in Vicarage Street from 1881, after Lord Bath sold him 51 Vicarage Street. Kelly's Directory for 1899 identifies Harraway as a Fellow of the Royal Horticultural Society (FRHS) and Harraway and Scott are listed as 'nurserymen, seedsmen and court florists'.

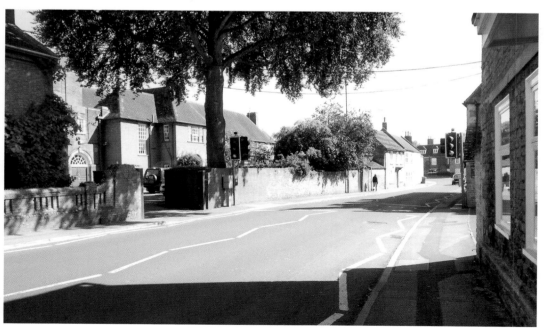

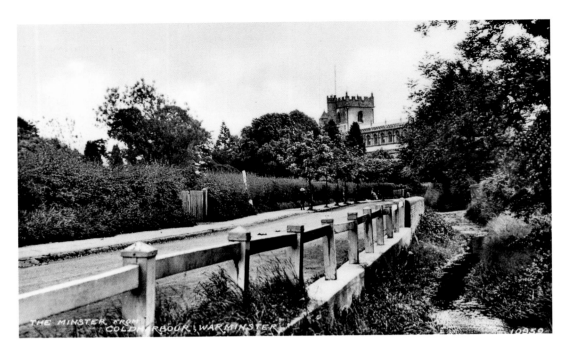

Cold Harbour

This view of the minster is from Cold Harbour to the north of the town. Just before the minster, on the right and adjacent to the road but just out of view, was, according to the 1899 Ordnance Survey Map, a substantial rectilinear structure, the size of a large swimming pool, labelled 'baths'. Today, long since filled in, no evidence of the baths remains. The photographer taking the top picture, about a century ago, would have been surrounded by fields on both sides of the lane.

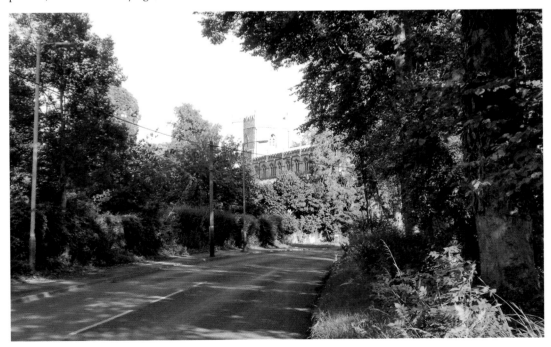

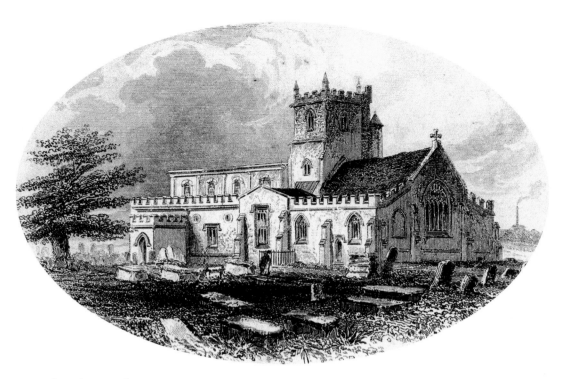

The Minster, Church Street

The minster is in fact the church of St Denys. It appears to have acquired its nickname 'the Minster' around the time of its rebuild in the late 1880s. Its vicar, once the most important individual in the town, was housed in the Old Vicarage, which subsequently became a boarding house for girls at Warminster School.

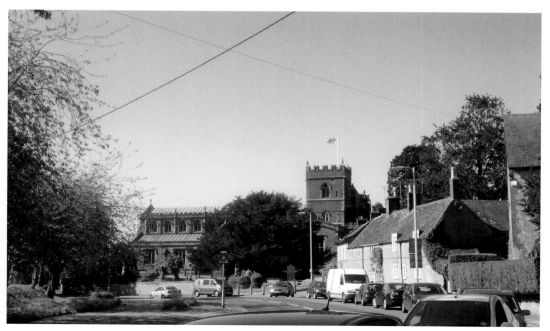

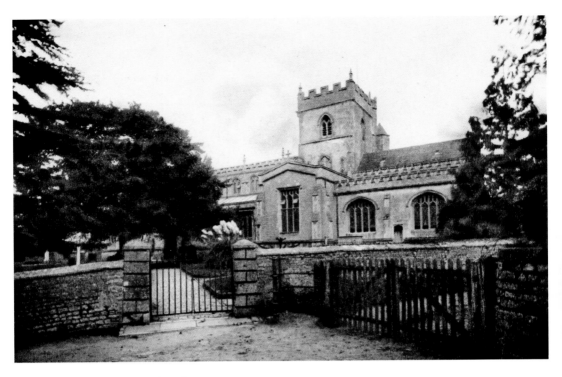

The Church of St Denys, Church Street

The name Warminster was recorded in the early tenth century and indicates the existence of a church ('minster') on the Were from at least that time. The thirteenth-century minster, the church of St Denys, after many substantial alterations over the centuries, was largely rebuilt in the Perpendicular style in the late 1880s.

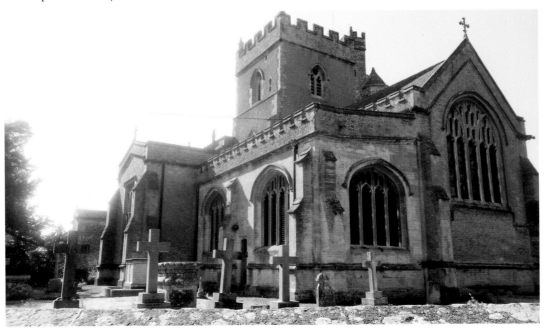

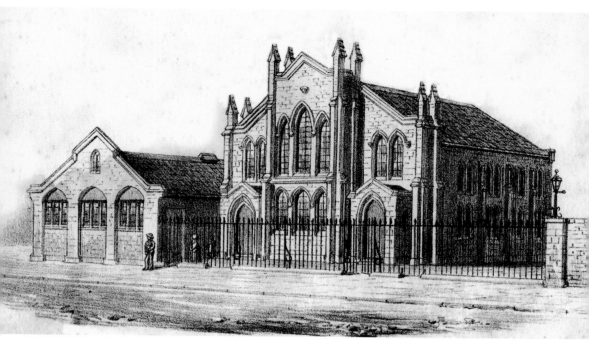

The Congregational Church, Common Close

The Common Close congregational church was founded in 1719. The impression above probably dates from the time of its rebuild in 1840. In 1983, following a great decline in the size of its congregation, the Congregationalists of Close Common merged with the methodists and now meet and worship at the Warminster United church in George Street. The congregational church and its neighbouring schoolrooms were pulled down in 1987 to make way for Kyngston Court.

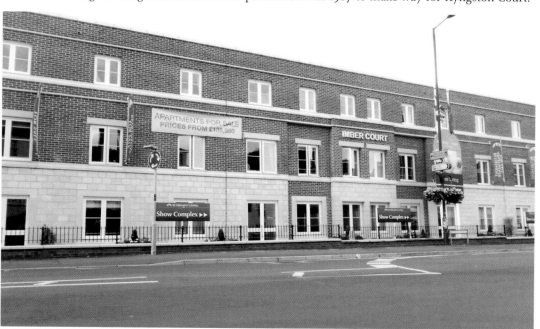

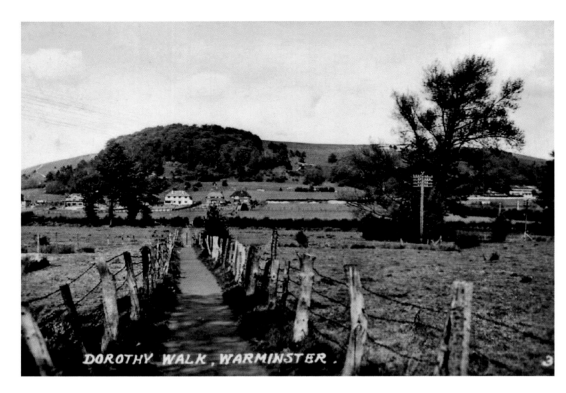

DOROTHY WALK, WARMINSTER.

Dorothy Walk

The view above of the lane, known as Dorothy Walk, was captured in 1932. Dorothy Walk remains as a footpath but, instead of heading off from beside the minster towards open countryside, it now leads towards the numerous residences on Portway Lane and Hollybush Road.

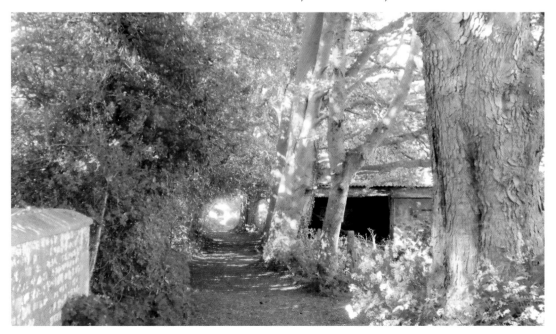

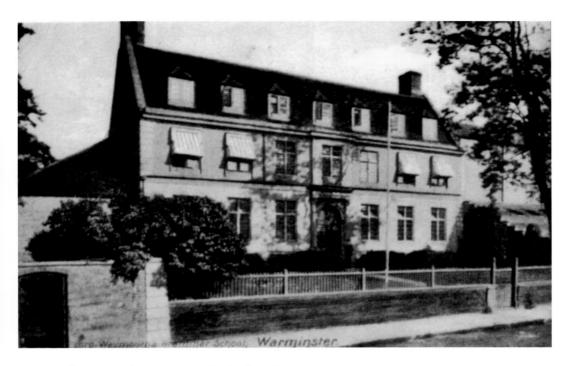

Lord Weymouth Grammar School, Church Street

The older photograph here was taken in 1904. The boys' boarding school was founded in 1707 by the first Viscount Weymouth, Thomas Thynne. The famous headmaster of Rugby School, Dr Thomas Arnold, immortalised in the pages of *Tom Brown's Schooldays*, was educated here between 1803 and 1807. In 1973 this school and St Monica's were combined to form the present co-educational Warminster School.

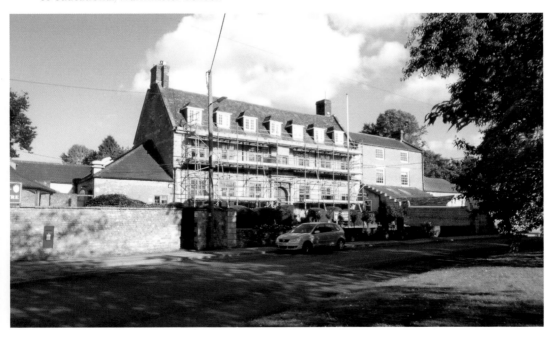

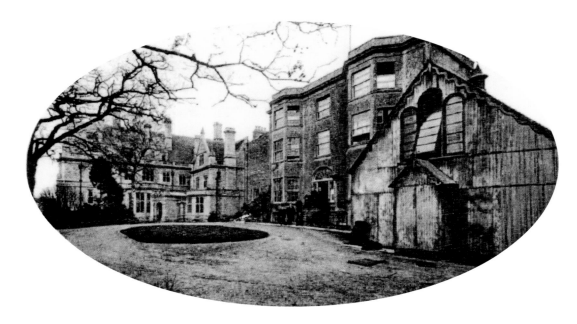

St Boniface College, Church Street

St Boniface Missionary College was founded by Sir James Erasmus Phillips, Vicar of Warminster, in Church Street in 1860. Shortly after this photograph was printed in 1905, the college was considerably extended into adjacent premises, and by 1948 it had an association with King's College, London, providing training at a postgraduate level for aspiring Christian missionaries. It was one very successful example of the considerable number of mostly short-lived minor educational establishments set up in Warminster in the nineteenth century.

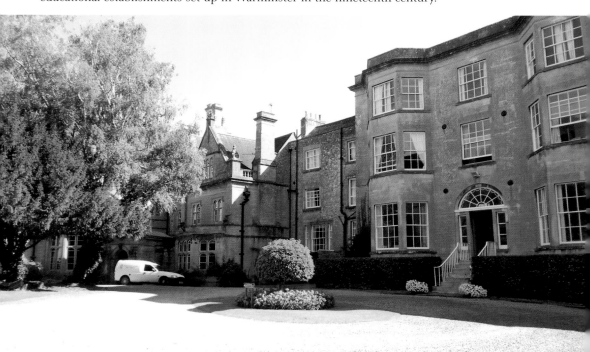

**The Blind House,
George Street**
This photograph
of the 'Blind
House', behind
what was once
Broadway Garage
and is now
a house, was
taken in 1932.
Its purpose is
unknown – local
tradition has it
that this was the
town lock-up, but
others believe it to
be a smokehouse
for curing
foodstuffs.

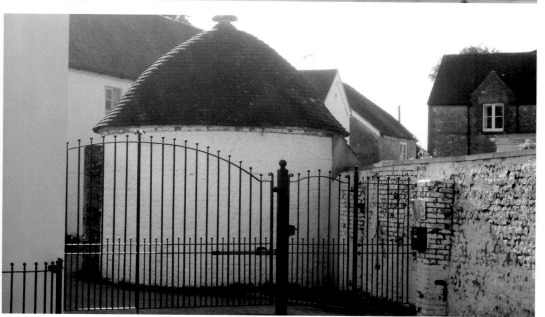

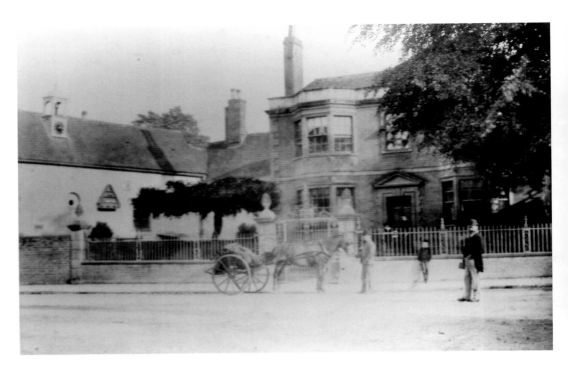

Craven House, Silver Street, 1912

The slightly blurred older photograph on this page shows Craven House, a Grade II listed building. Built of stone and brick, it was largely constructed in the eighteenth century, although some elements date back to the seventeenth. Pineapples, the fashionable fruit of the elite of Georgian England, decorate its moulded capping and act as a symbol of hospitality. Among its many fine interior features is a richly decorated marble fireplace. Since this photograph was taken in 1912, the stables have been converted into apartments. Between 1949 and 1974 this was the site of Warminster's council offices.

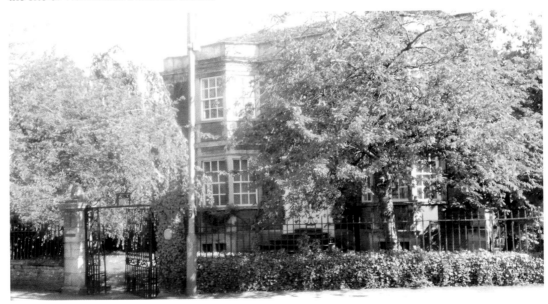

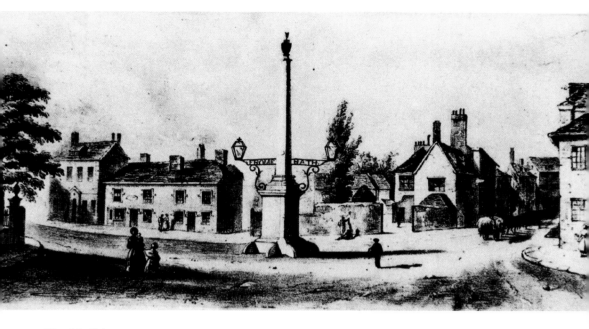

The Obelisk

The Obelisk, at the junction of Church Street, Vicarage Street and Silver Street, dates from 1783 – or 1782, as Howell suggests. It marked the enclosure of remaining open fields and 'wastes' by an Act of Parliament – something that was clearly perceived by the Commissioners responsible for the enclosure as a civic improvement well worth celebrating. The fountain and troughs at its base, now serving as beds for flowers, were added in 1896.

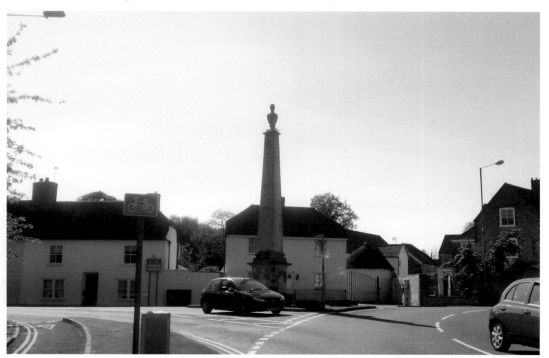

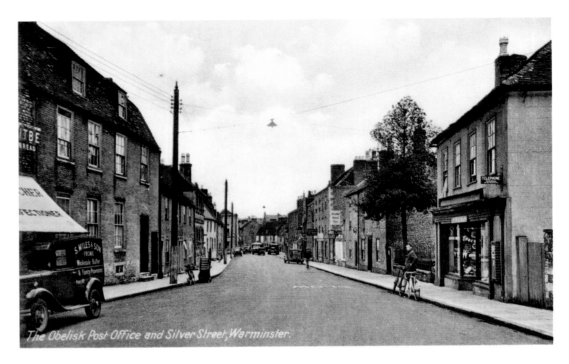

The Obelisk Post Office and Silver Street, Warminster.

The Obelisk Post Office, Silver Street

The Obelisk post office, seen on the right-hand side of the mid-twentieth century photograph (*above*), took over the premises of Albert Dale's shop, which sold pretty much anything with wheels, including bicycles, motorbikes and Austin Sevens.

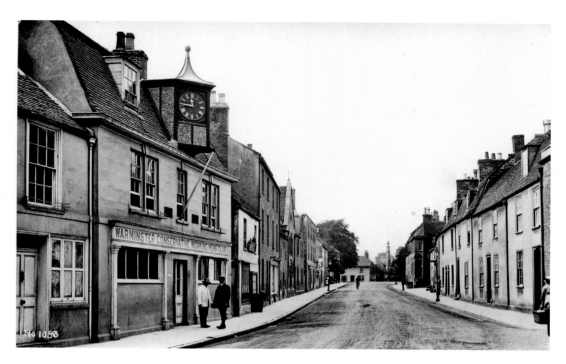

The New Inn, Silver Street

In 1908 the Conservative Working Men's Club was established on the premises of the former New Inn, shut down in 1907 under the Consolidation Act, which was designed to restrict the number of purveyors of alcohol. Its attractions included a coffee room, a smoking room, a games room and a reading room. The club subsequently moved to Church Street before ending up at Prestbury House. The New Inn is now an antiques shop. The photograph above was taken in 1915; the clock was erected in 1913 in memory of John Hall. It can still be seen but has been relocated on a building further along the street.

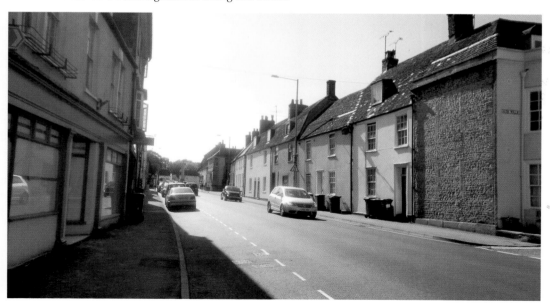

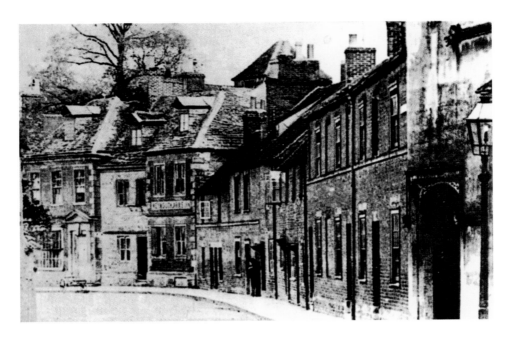

Emwell Street

An excavation in Emwell Street in 1979 revealed evidence of Warminster's Anglo-Saxon past. The images above show both the school and the nearby Weymouth Arms pub. All of the buildings in the foreground of the earlier picture have been demolished and replaced by a car park.

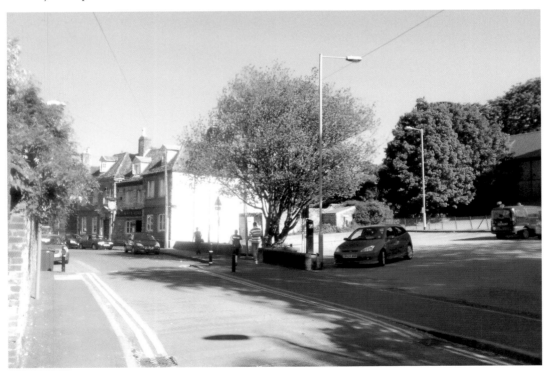

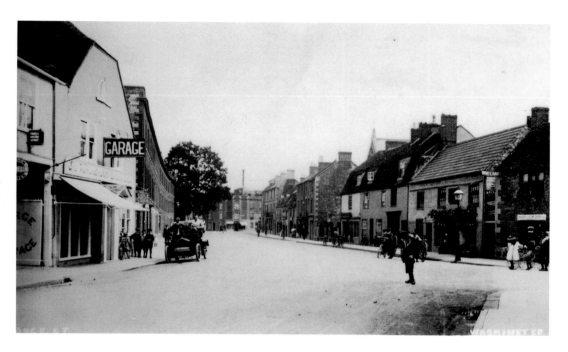

Silver Street

This delightful photograph of Silver Street dates from the early twentieth century. The garage and vintage car on the left commemorate the dawn of motoring, when the car was still a rarity and the regular modes of transport were horse-drawn gigs and carts, and the more recent invention of the bicycle. In the distance looms the chimney of a brewery. To the right stands the White Hart, now a shop selling beds. Both the garage and the brewery chimney have gone.

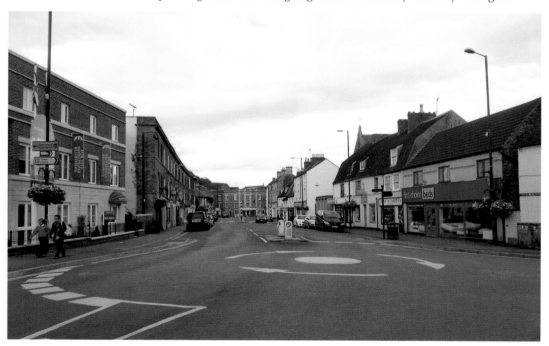

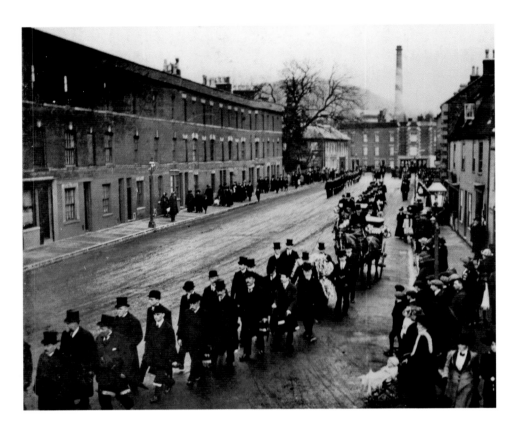

George Street

This gloomy scene of a funeral cortège on a cold winter's day in 1912 provides a fascinating snapshot of George Street a century ago. Judging by the crowd of well-dressed participants and onlookers, the horse-drawn hearse carries the body of a much respected person. A line of men seemingly standing to attention in the middle of the road suggests a military connection. In the modern photograph a vintage Citroën van draws the attention of pedestrians.

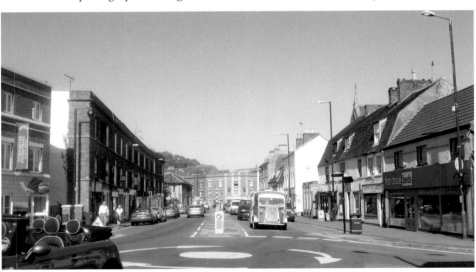

The United Church

The appearance of the United church on George Street has not been done any aesthetic favours by the minor extension at the front of this former Victorian Wesleyan establishment. The older photograph was taken in 1907 and the building dates from 1861. John Wesley visited the town over 100 years earlier when, in 1753, he preached on Warminster Common.

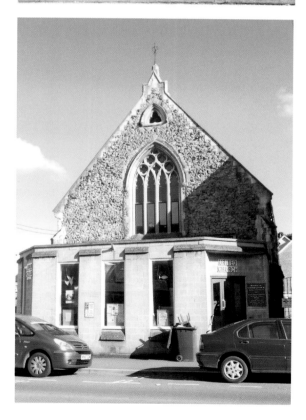

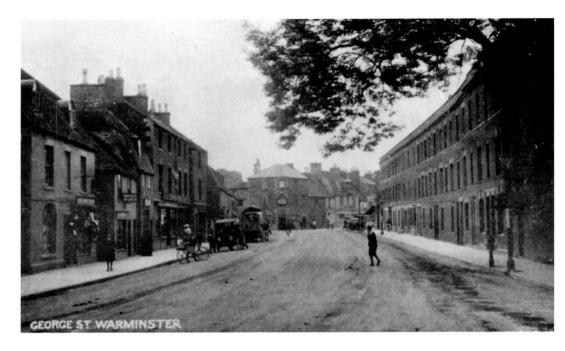

George Street

George Street has long been an important area of commercial activity. In the past its premises offered everything from charabanc outings, bicycles and motorbikes, to leather goods, made-to-measure boots and shoes, fresh fish, and animal feed.

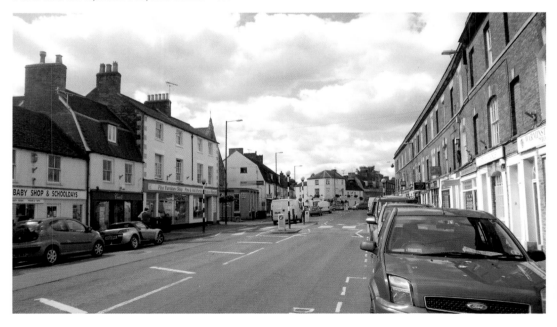

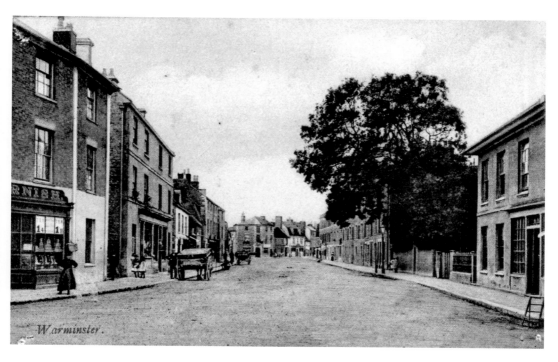

George Street

The older photograph on this page shows John Cornish's shop at No. 3, George Street. This was a grocer's and wine merchant's, and continued as a food store for much of the twentieth century. The woman facing the camera, hands on hips in a proprietary manner, could well be the shopkeeper – Mrs Cornish perhaps?

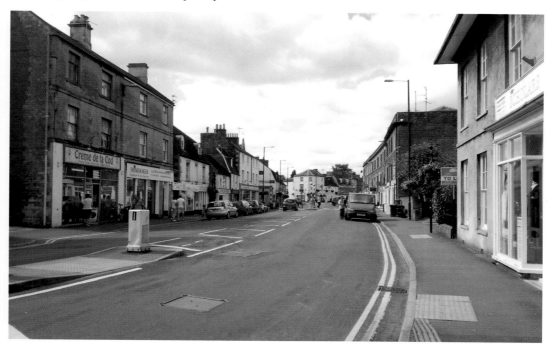

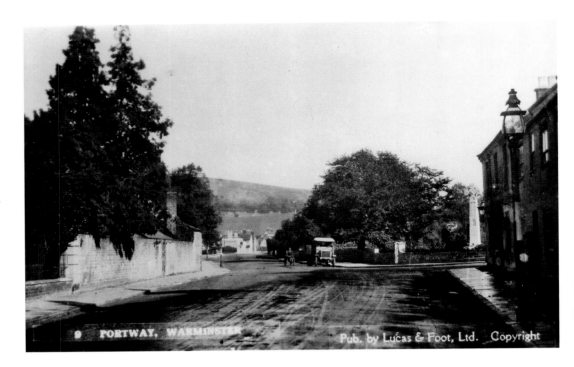

Portway

Until 1990 Portway was home to the town surgery, established in premises built by Dr Robert Lewis Wilcox in 1901. The Warminster Community Hospital is off Portway but the town's surgery has relocated to the Avenue. In the 1890s, at a time when the town was suffering from a shortage of water, an old Portway well was reopened to supply water specifically for cleaning the streets of horse manure – the principal pollutant of road transport in the age before cars!

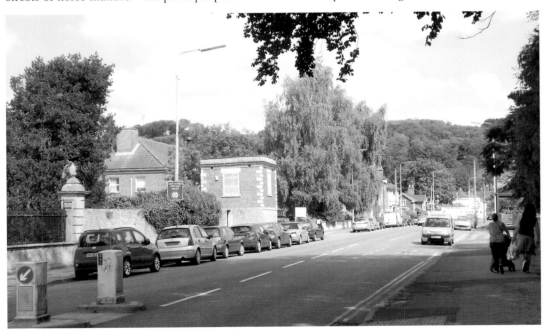

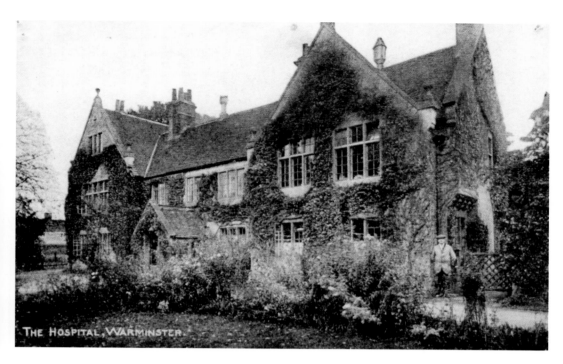

THE HOSPITAL, WARMINSTER.

The Cottage Hospital, Portway

The photograph above dates from 1917 and depicts Warminster's Cottage Hospital, built in 1866 where Portway Farm once stood. It was replaced by the present Community Hospital in 1932. Another hospital – an isolation hospital – was built on the Bradley Road in 1915.

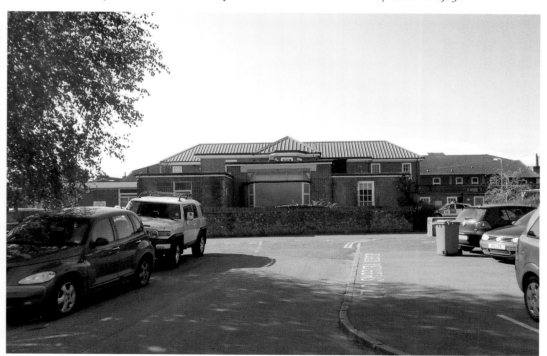

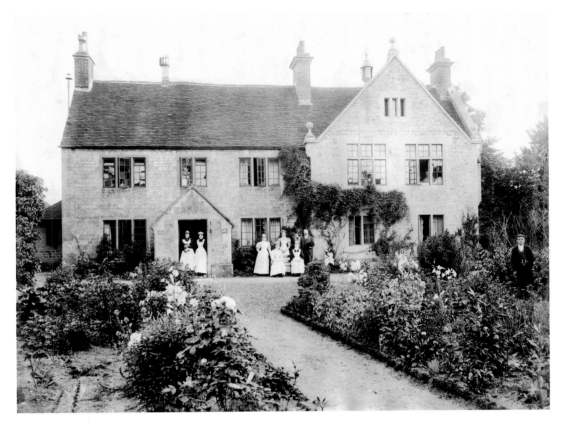

The Cottage Hospital, Portway

The original seven-bed Cottage Hospital was established in 1866, in what was formerly Portway Farmhouse and its garden. The property belonged to Lord Bath, who offered it rent-free. The photograph above is thought to date from about 1870. It shows nurses on the right and two maids at the entrance, one of whom is cradling a cat. In the top right a female patient is sitting up in bed gazing towards the camera through an open window.

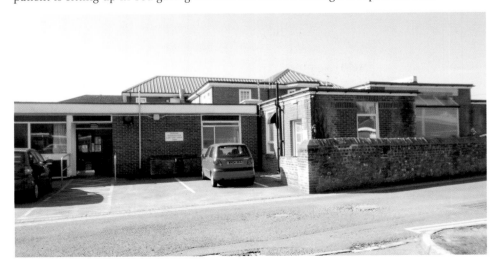

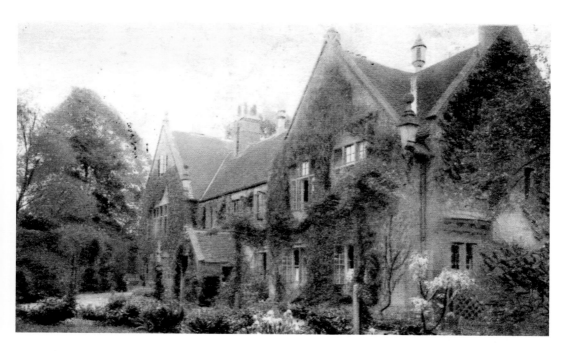

The Cottage Hospital, Portway

The Cottage Hospital was enlarged in the 1890s but proved unable to meet the local demand for beds and treatment. Thus, in 1928, a new hospital building, to be known as Warminster Hospital, was erected on land adjoining the original premises, and the old farmhouse was pulled down shortly afterwards.

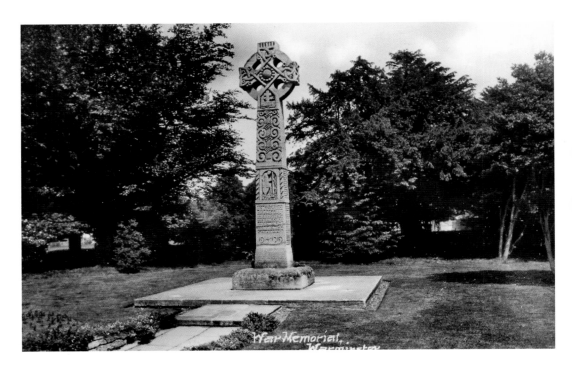

The War Memorial, Portway

The war memorial at the junction of Portway and the Avenue was erected in 1921 on land gifted to the town by the 5th Marquess of Bath. It listed the names of 115 men who lost their lives during the First World War. Since the photograph above was taken in the 1920s, a further dedication of the memorial in 1949 commemorated the fifty-two names added after the Second World War. The sculpture nearby arrived in 2010; it represents the infamous trenches of the Great War.

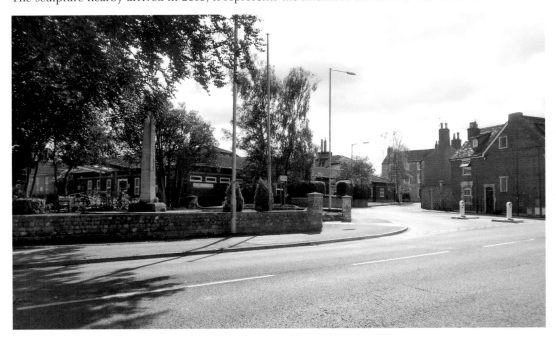

Portway House

Behind these splendid gates stands the principal building on Portway: the handsome Georgian residence of Portway House, erected in 1722. It was the home of local clothiers the Middlecotts, once Warminster's wealthiest family. In building his home, Edward Middlecott had its frontage entirely faced in finely cut ashlar. The family subsequently sold Portway House to the Longleat estate in 1820, and in more recent times it has served as premises for Warminster's library (1958–81) and as council offices. It has since been converted into a number of flats and apartments.

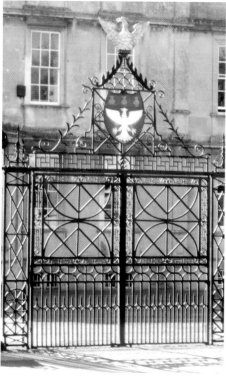

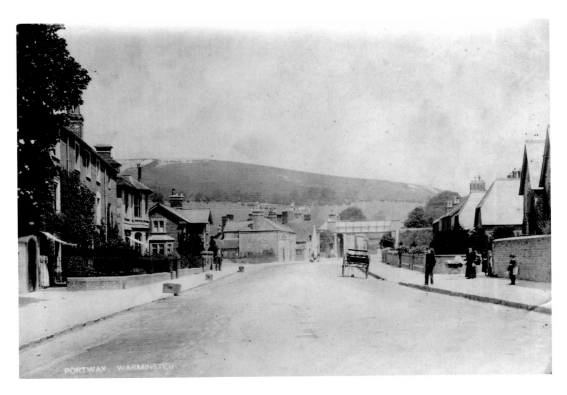

Portway & Arn Hill

Arn Hill, shown here beyond Portway, like other hills forming the Downs, is the site of prehistoric burial rites. Two barrows of Bronze Age antiquity were largely destroyed when the local golf course was developed on the site in the early years of the twentieth century. Workmen unearthed two cremation urns and various other interesting finds, now kept at Devizes Museum.

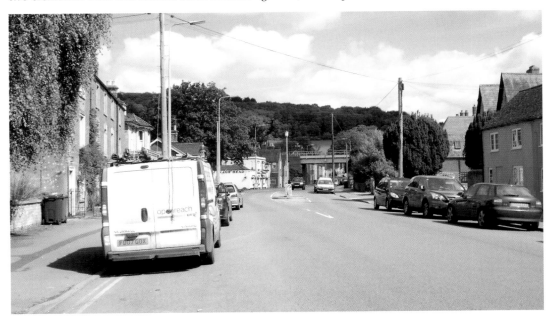

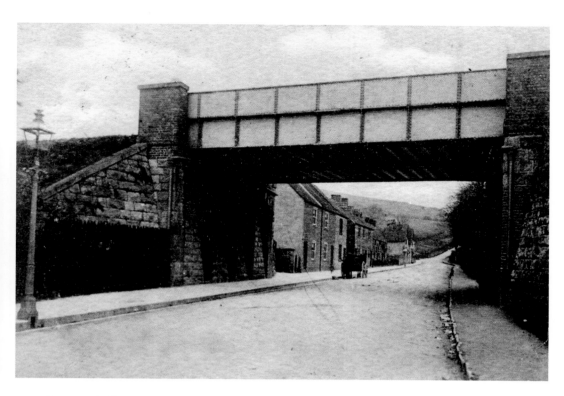

Portway Bridge, Portway

Warminster remains a very busy station and provides an excellent commuter service to London. Near to an inn called the Nag's Head, the original Portway Bridge, replaced in the 1880s by a wider utilitarian structure, was built to a pattern of Brunel's own design.

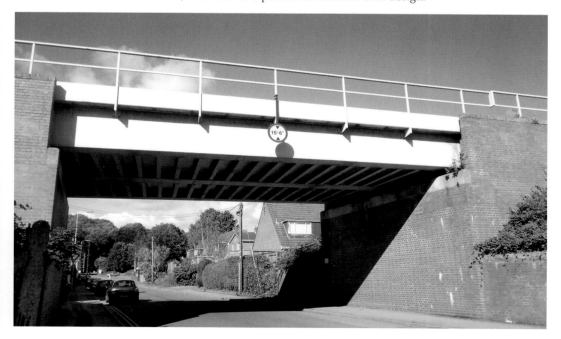

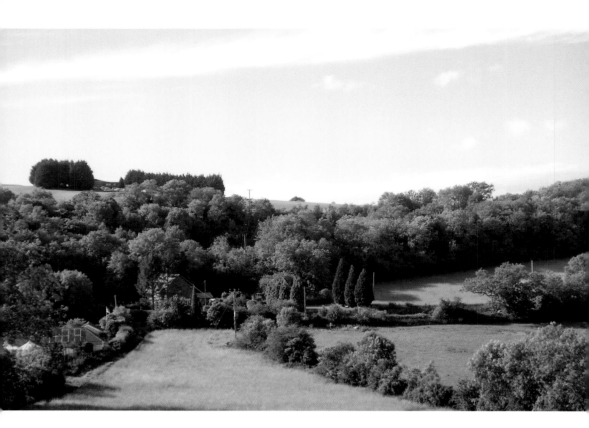

The Golf House, Arn Hill

With a new nine-hole course on Arn Hill, the golf clubhouse was opened on 3 April 1907. Established as the Warminster Golf Club in 1892, its broad membership caused it to change its name to the West Wilts Golf Club in 1898. In 1906 the nine-hole course became an eighteen-hole. The land, originally leased from Lord Bath, was offered for sale to the club in 1914. The original club house was replaced in 1953.

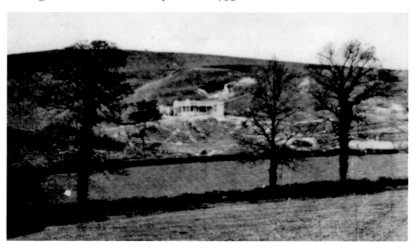

The Downs & Copheap

Copheap has been a local landmark for people living in its vicinity for thousands of years. Here a substantial late Neolithic or early Bronze Age round barrow (burial mound) was constructed. When Sir Richard Colt Hoare opened it in 1809 he found four skeletons including those of a woman and infant buried side by side. The grave goods discovered included a seashell, ivory beads, pieces of worked flint and a perforated fragment of a stag's antler.

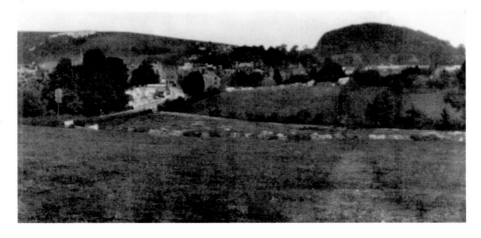

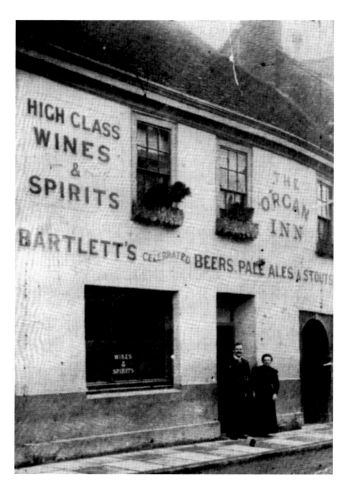

The Organ Inn, High Street
The Organ Inn, 49 High Street, is a long-established pub close to the centre of the town. Following its recent restoration after a lengthy stint as the Warminster Fish and Fruit Shop, its present owners now proclaim it as Warminster's 'oldest and newest public house'. Included in the Wyle Valley Art Trail, it displays artwork and also provides a venue for a range of community events. It is a considerably smaller pub than it once was, having lost space to retail outlets on both sides.

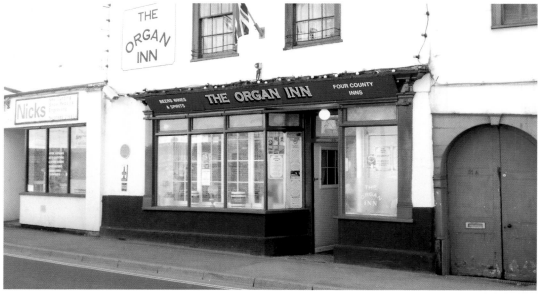

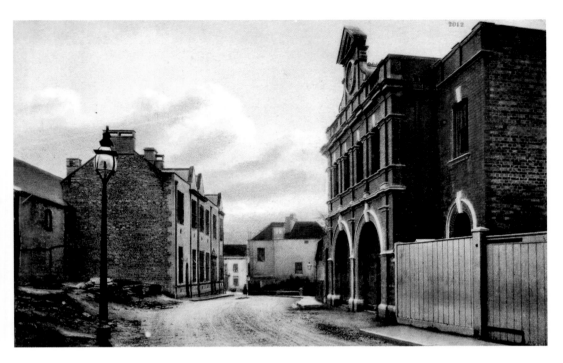

The Fire Station & Technical School

Warminster's modern fire station, opened in 1966, is on Portway, but its predecessor, together with the technical school, occupied sites on the Close (*above*). The Technical School is the building on the left and the fire station, manned by volunteers, is on the right. It was established in 1905 and taken over by the District Council in 1913.

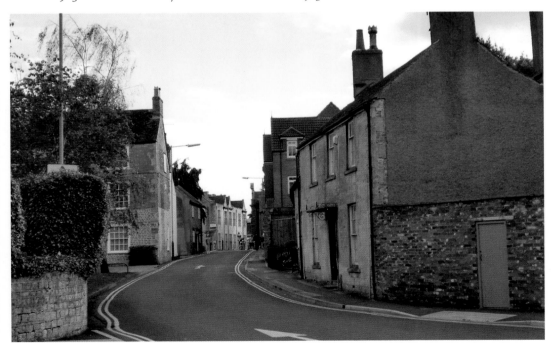

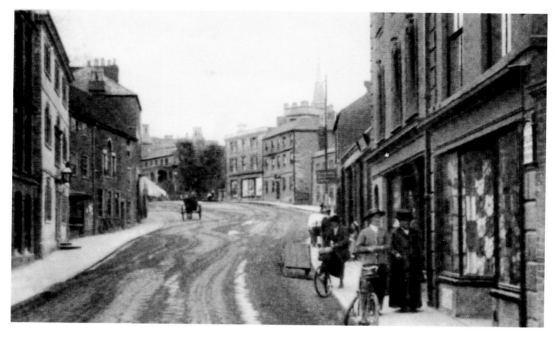

Silver Street

This view, looking towards the junction of Silver Street and George Street, reveals how little the general aspect has changed since the older photograph was taken in 1902.

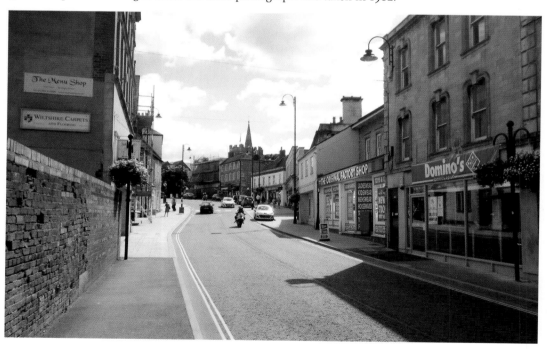

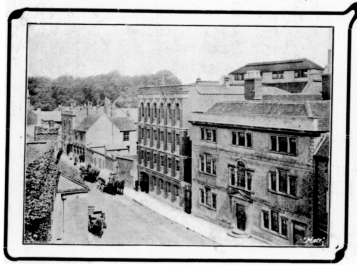

Bartlett & Co.

The history of commercial malting in Warminster can be traced back to the sixteenth century, and the production of Warminster malt appears to have been a lucrative business. In 1720, Warminster had thirty-six malthouses, supplying Bristol and many parts of Somerset. The malting tradition in the town, though in decline, led to the development of a number of commercial brewing concerns in the nineteenth century, including that of James Bartlett & Co. in the High Street. The business was formed around 1830 and continued until after the First World War when it was taken over by Usher's, Trowbridge's major brewery, before its closure and the conversion of its red-brick premises, erected in 1865, to shops and showrooms.

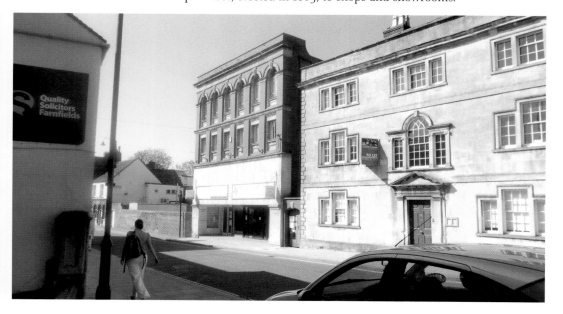

41

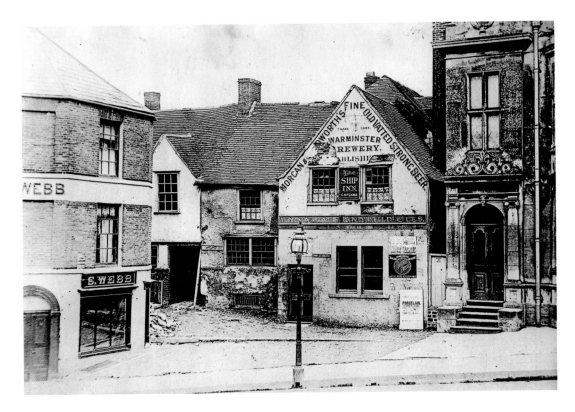

The Ship Inn, Portway

This old photograph shows the derelict Ship Inn, next door to the Atheneum, shortly before its demolition in 1901. It advertises good stabling, and Morcan & Wadworth's 'fine old strong vatted beer'. It appears to have been a Warminster Brewery tied pub leased by G. Hitchings. The billboard on the right advertises the sale of china, porcelain and earthenware in the town hall. Next door is the elaborate portico entrance to the Atheneum. S. Webb's drapery shop can be seen over the road.

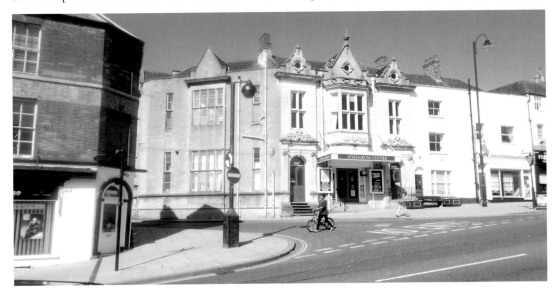

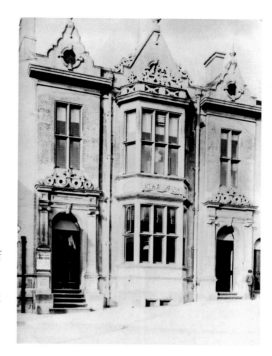

The Athenaeum, High Street

Established by local philanthropists in the early 1850s, the Athenaeum initiative aimed 'to afford intellectual enjoyment as a means of cultivating literary taste and with the help of the people of Warminster, improve the partial education of pupils at the British and National Schools, rendering necessary on account of the early age at which children were removed from such schools'. After a few years of meetings in a variety of locations, including the Literary Institution and the town hall, the site of the London Inn in the High Street was acquired and the purpose-built Athenaeum came into being, replete with classrooms, a library, a recreation room, a reading room and a lecture theatre. Since then it has had a chequered history but now flourishes once again as a very active venue providing a wide range of cultural opportunities for the town.

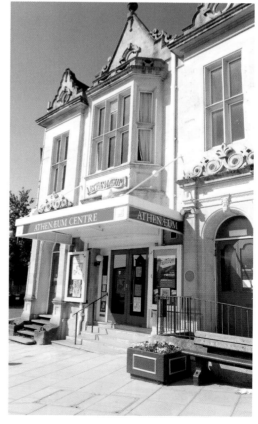

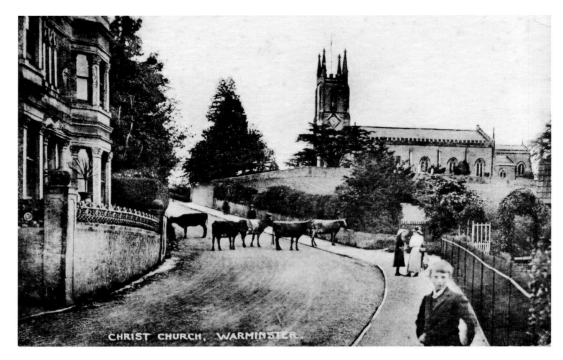

Christ Church

In this photograph, taken at time when cars were still a rarity, the cattle in the road seem to be wandering about aimlessly without anyone in attendance. Completed in 1831, Christ Church was built on the top of Sambourne Hill to serve the spiritual and other needs of the inhabitants of Warminster Common. It was designed to be large enough to accommodate a congregation of 800. Trees obscure the view of the church in the recent image.

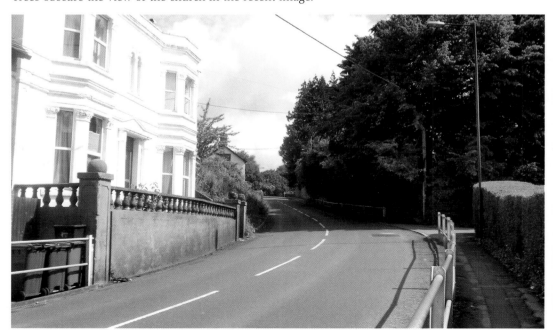

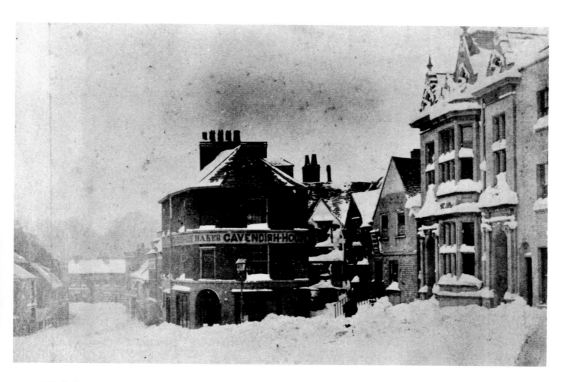

High Street

This very early image, dating back to 1881, shows the High Street on a snowy winter's day. Kelly's Directory for 1899 lists a range of businesses on the High Street, including an ironmonger's, a hairdresser's shop, a draper's, a baker's, a butcher's shop, a tailor's, and the premises of a photographer named Frederick Futcher of 36 High Street. His motto, one worthy of the compilers of this volume, was 'Secure the Shadow 'ere the Substance Fades'.

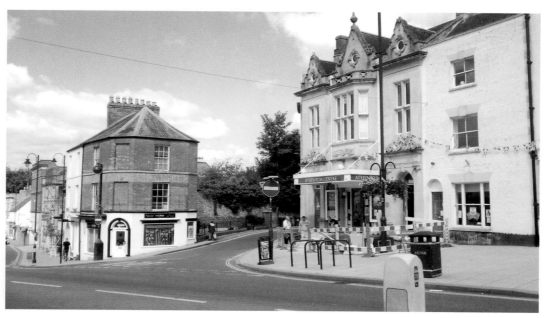

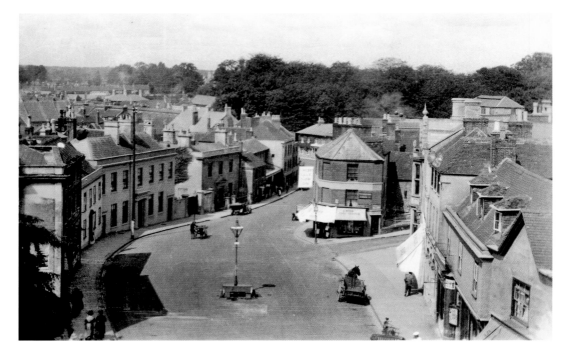

High Street & George Street

The photograph above reveals High Street and George Street on a sunny day at the start of the twentieth century. This was the dawn of the era of the motor car and the street is quieter and less congested than it usually is today. In the centre is S. Webb's drapery shop, from which, according to a 1903 advertisement in Coates' Directory, one could purchase 'a large and varied assortment of useful and fancy goods suitable for the prevailing season'. A large banner reading 'Webb's Sale Now On' hangs over the road.

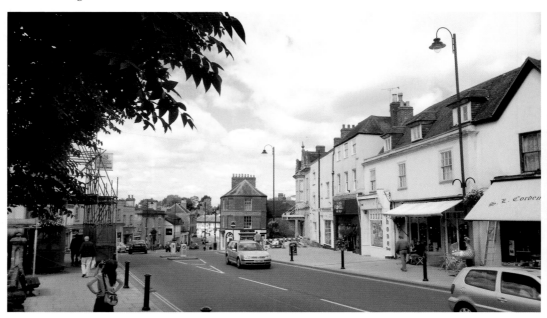

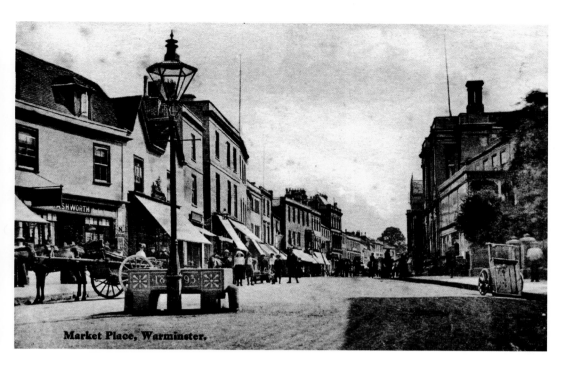

Market Place, Warminster.

High Street

This view looking up the High Street presents a busy scene at the start of the twentieth century. In the foreground can be seen two distinctive and contemporary pieces of 'street furniture' – a gas lamp and a horse trough dated 1893 – both of which, in a short while, would become obsolete.

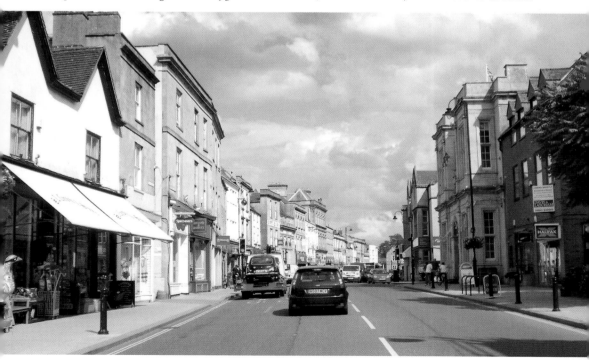

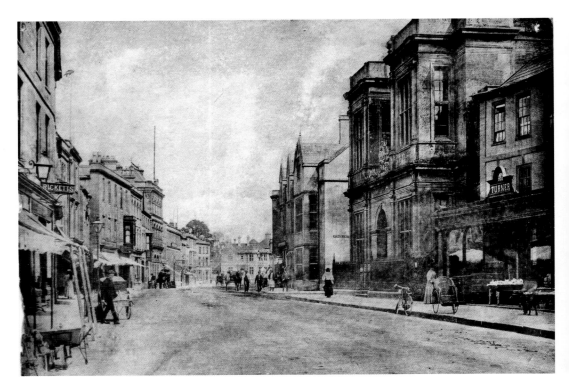

Market Place & Town Hall

This old view of the Market Place, showing the town hall on the right, dates from around 1905. The town hall has survived intact but the adjacent shop, Turner's, was knocked down and replaced in 1982. 'House furnisher' Herbert Turner's premises were listed in Kelly's Directory for 1899 as a china and glass warehouse. George Ricketts, whose shop can be seen on the left, was a 'hosier and outfitter'.

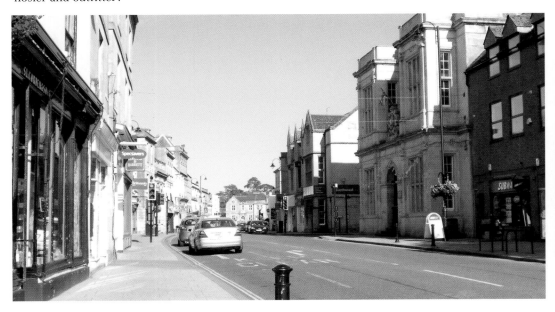

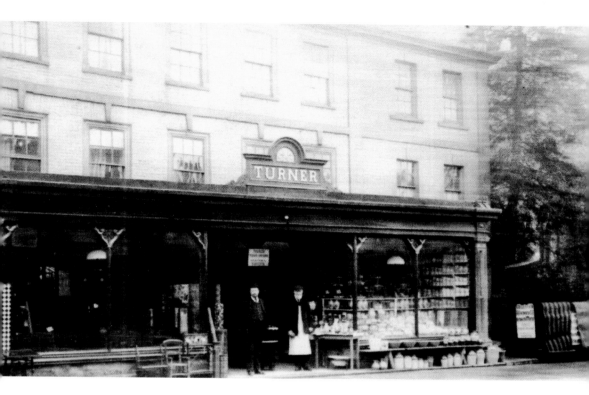

The Wiltshire Furnishing Depot
In the early twentieth century, Turner's evolved into the Wiltshire Furnishing Depot and, as shown above right, it acquired a new two-storey shopfront in the fashionable design of the period.

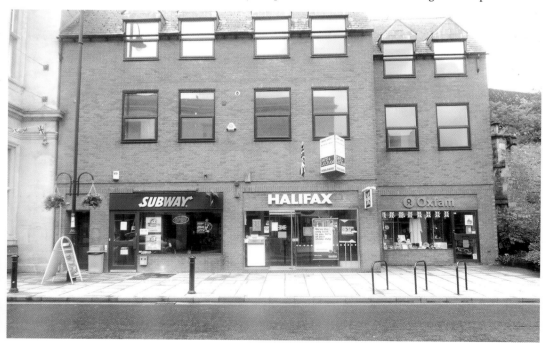

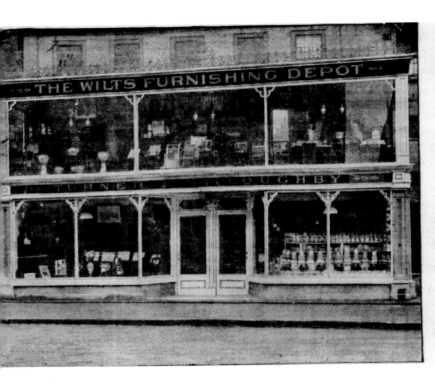

THE WILTS FURNISHING DEPOT

TURNER & WILLOUGHBY

The Wiltshire Furnishing Depot
The two-storey shop was demolished then later rebuilt into the block of flats it is today, with three retail spaces at street level.

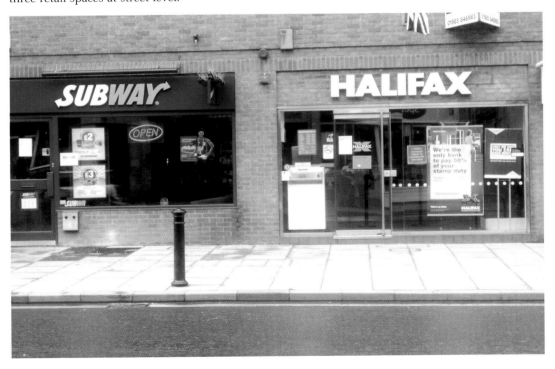

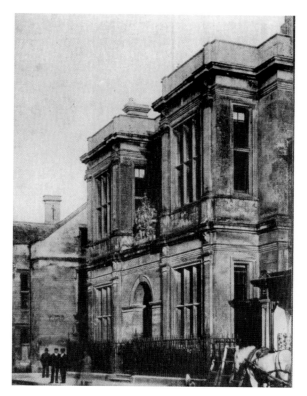

The Town Hall, High Street
Warminster's seventeenth-century principal administrative building, providing a court, an assembly room and a gaol, was located at the west end of the High Street before its demolition in 1832. It was replaced by the town hall where Market Place and Weymouth Street meet. The architect was Edward Blore, commissioned by the Marquess of Bath. The archive photograph was taken in 1900.

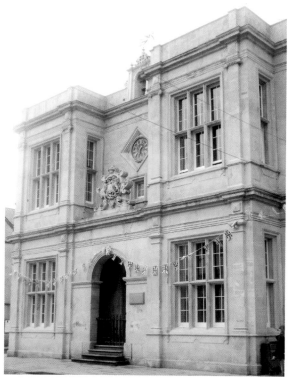

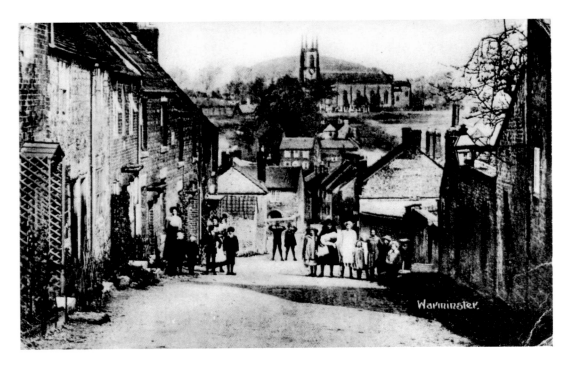

Bread Street, Warminster Common

The view above shows some of the inhabitants of Bread Street on Warminster Common, photographed in around 1900. Their local church, Christ Church, stands on Sambourne Hill in the background. One of the occupants of Bread Street at around this time was Constable Frank Smith of No. 25 who policed this notorious neighbourhood.

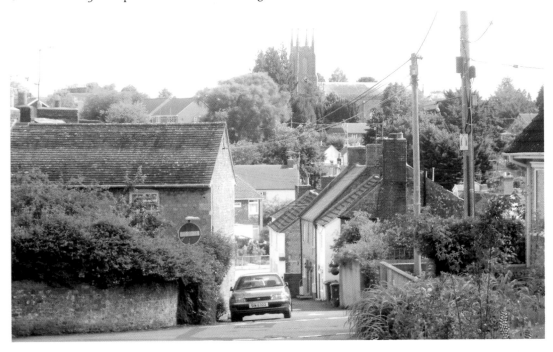

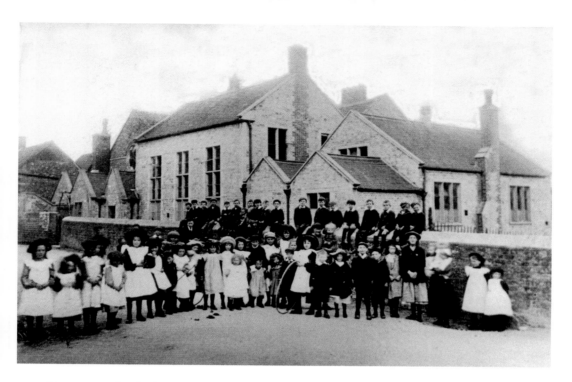

Newtown School, Chapel Street

The photograph above dates from around 1900. It shows a group of Newtown School's pupils – the boys wearing Eton collars, and the girls dressed in pinafores and bonnets. The hoops held by a couple of the girls suggest it was taken during a break between classes. Adjacent to and associated with the Independent Methodist chapel, Newtown School opened in 1859 and closed 100 years later in 1959. It was established by local philanthropist William Daniell for the impoverished population of Warminster Common.

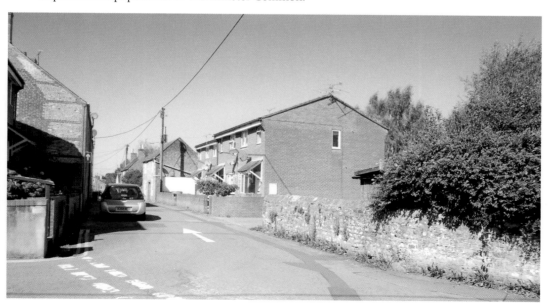

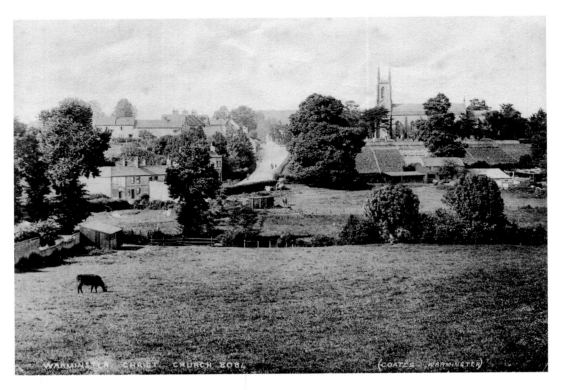

Christ Church

This charming view of Christ Church on its hill shows it in its original rural setting, when it was still separated from the hustle and bustle of the town centre by farms and fields. Beyond the houses on the left, on the periphery of the hamlet of Sambourne, the Warminster Union Workhouse was built in the mid-nineteenth century. It survives to this day, having been turned into flats and houses.

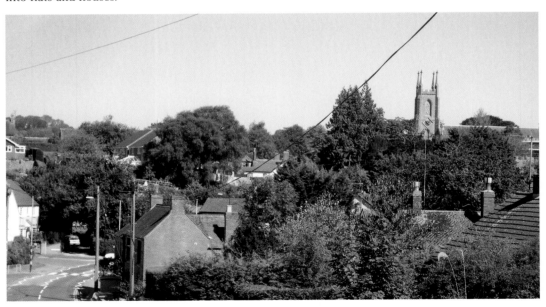

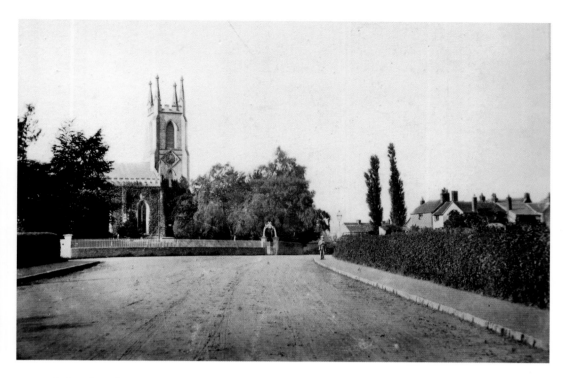

Christ Church

This view of Christ Church from Weymouth Street was probably taken at a time when this part of the road was still simply called, or had recently been known as, New Road. The Ordnance Survey Map for 1899 shows this to have been entirely undeveloped between Sambourne and the town centre. The land on both sides was divided into fields, one of which already served as the town's football ground.

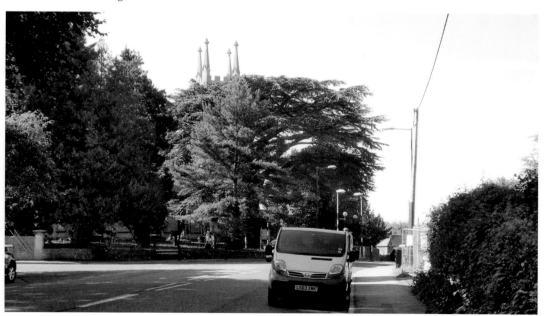

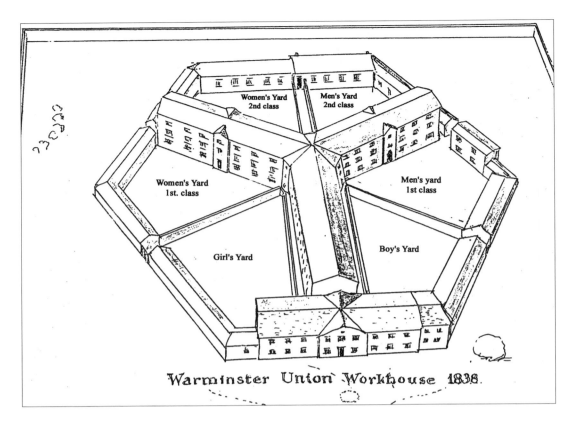

Warminster Union Workhouse 1838.

Warminster Workhouse, Sambourne

Warminster's first workhouse, built in the late 1750s, was in Brook Street, in premises now occupied by the Snooty Fox. In 1836, however, in line with the Poor Law Amendment Act of 1834, a much larger 'union' workhouse, was built at Sambourne. It was built on the Kempthorne's Star design and could accommodate 300 paupers kept in prison-like conditions. A grim 8-foot-high wall enclosed it. Eventually, by the middle of the twentieth century, it became Sambourne Hospital, providing care for the elderly, before being developed into housing in the late 1990s.

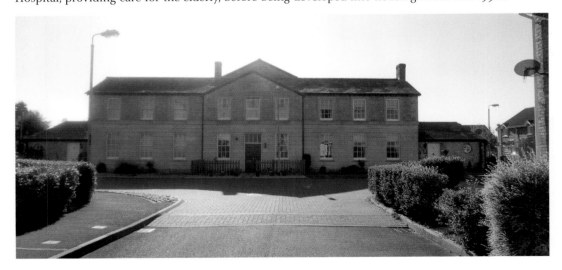

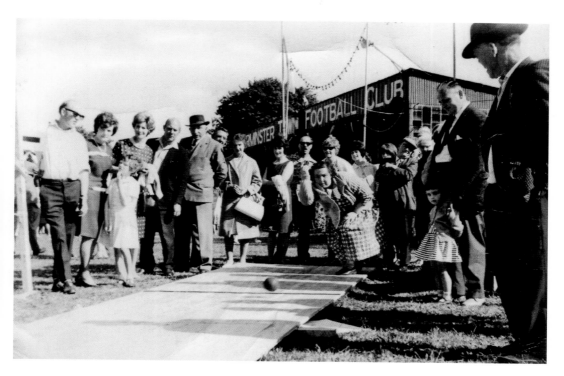

Football Ground

The football club at Christ Church has been a focus for members of the local community for well over a century, and not just for its nominal sport, as shown in the photograph at the top of the page! Over the years the club has won numerous cups and titles.

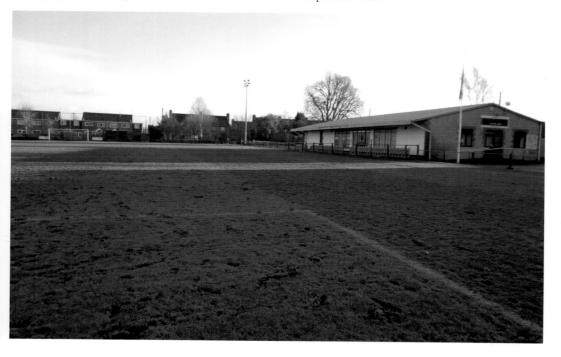

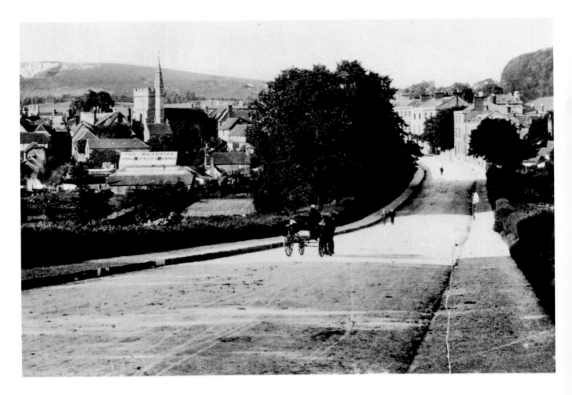

Weymouth Street

In the earlier image of this view looking along Weymouth Street towards the town centre can be seen the attractive Chapel of St Lawrence with its distinctive bell tower. The chapel is unusual in having a clock, still wound each day, without a face; it was installed in 1765. It dates from the thirteenth century. Each night its 'curfew' bell is still rung (automatically) at 8 p.m., but the old tradition of ringing again at 4 a.m. to awaken the townsfolk is no longer maintained!

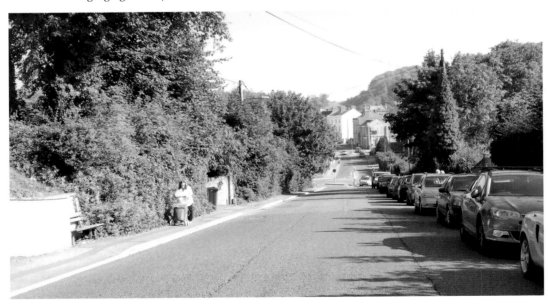

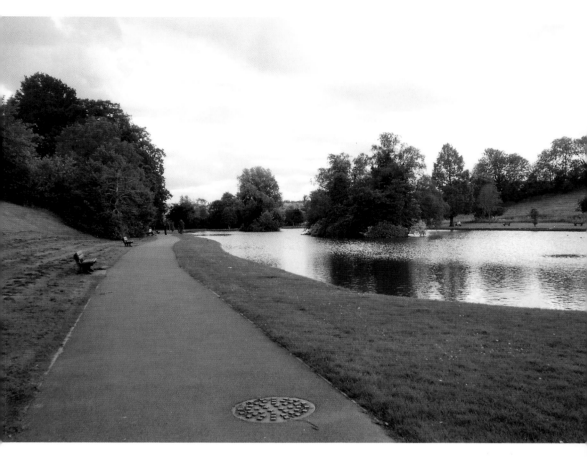

The Lake Pleasure Grounds

More commonly known these days simply as the 'Park', Warminster's Lake Pleasure Grounds are among its finest assets. They date from 1924, around the time when the picture postcard below was produced, and now include: a substantial boating lake, a paddling pool, children's play areas, tennis courts, a bandstand, and a putting green.

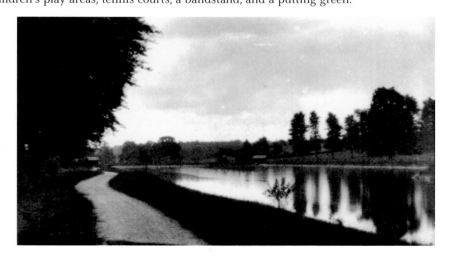

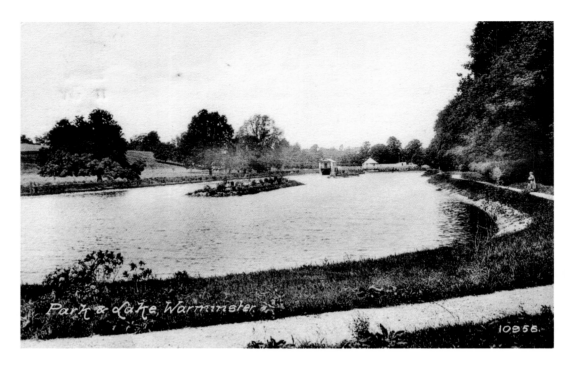

Park & Lake, Warminster

Warminster Park
The formal opening of the Park took place on Saturday 26 July 1924. The Marquis of Bath made his opening speech at 4 p.m. and the subsequent celebrations included fireworks, sports competitions, and a performance of the Warminster Town Band on the new bandstand.

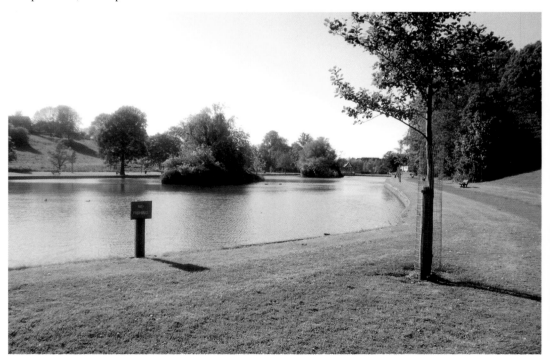

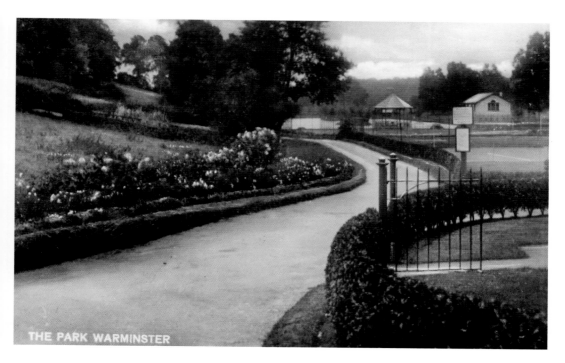

THE PARK WARMINSTER

The Park Lake

The Park was laid out on the site of the town's rubbish pit, a marshy wasteland well-suited to the creation of a small lake. The open-air swimming pool, next to the Weymouth Street entrance gates and part of the original plan, was filled in 1997 and now serves as an attractive and peaceful sunken garden. The children's paddling pool, constructed in 1947, remains a very popular attraction on warm summer days.

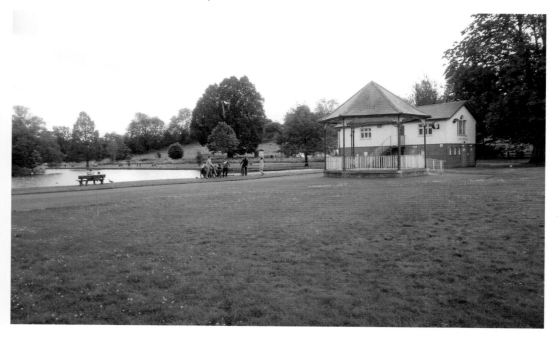

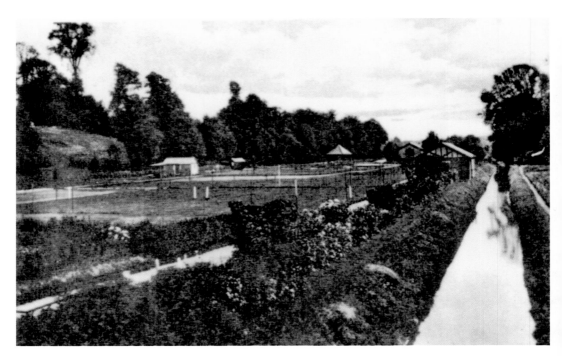

The Park Tennis Courts
The Park Tennis Club was formed after the Park was created in the 1920s. It became the Warminster & Westbury Tennis Club after the Second World War but, since 1974, has simply been the Warminster Tennis Club, the town of Westbury having established its own.

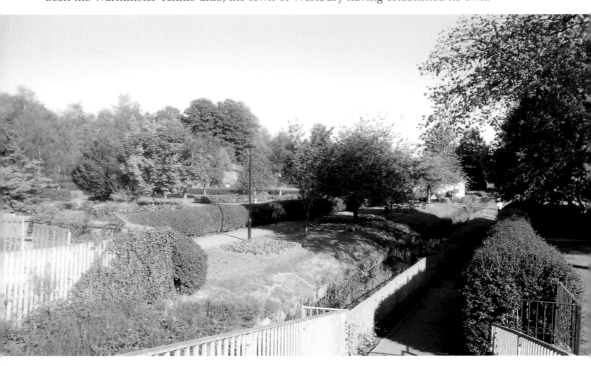

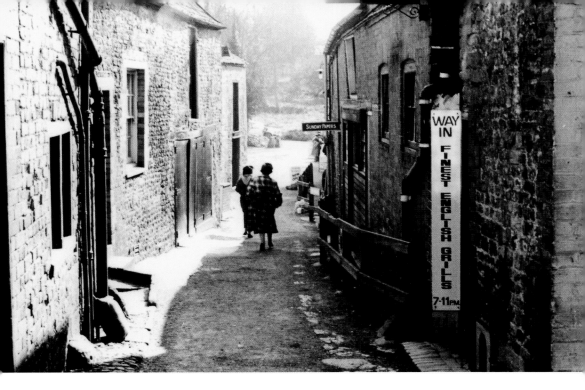

Chinn's Steak House, Chinn's Court
In the picture above, the signs on the right advertising 'Finest English Grills 7–11 p.m.' and 'Watneys Ales' identify the popular steakhouse in the cellars below a coffee shop. This photograph is likely to date from the 1960s. In addition to their steakhouse, the Chinns were well known for their butcher's shops in Weymouth Street and Market Place.

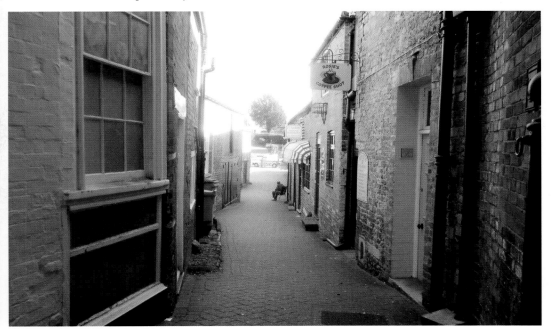

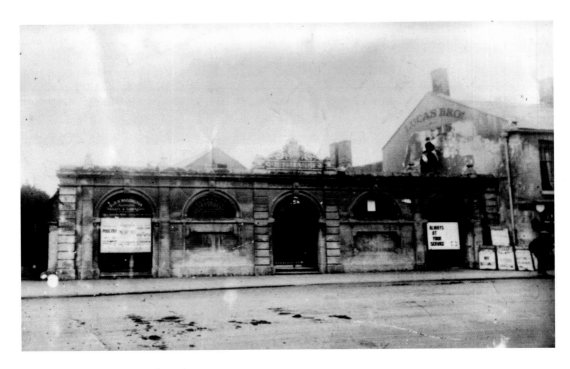

The Corn Exchange, Market Place

This Market House was built in 1855 and helped restore the town's position in the buying and selling of corn after it was challenged by the rise of markets in surrounding towns that had benefited from the arrival of the railway and, in some cases, the canal. Nevertheless, by the end of the century Warminster's corn trade had collapsed. It now provides premises for shops selling clothing and coffee. The earlier photograph dates from the early 1920s.

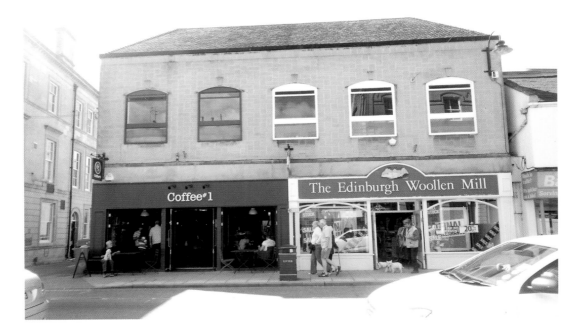

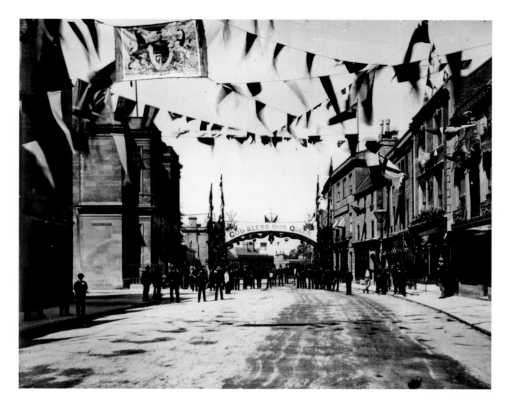

Jubilee Celebrations, High Street

The image above commemorates Queen Victoria's Golden Jubilee in 1887, celebrating the first fifty years of her reign. The town hall, at the junction of Weymouth Street and the High Street, is on the left-hand side of the picture. More recently in 2012, when the photograph below was taken, Warminster put out flags and bunting once again in honour of Elizabeth II's Diamond Jubilee, marking her sixtieth year on the throne.

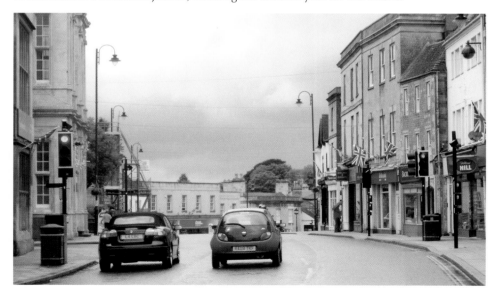

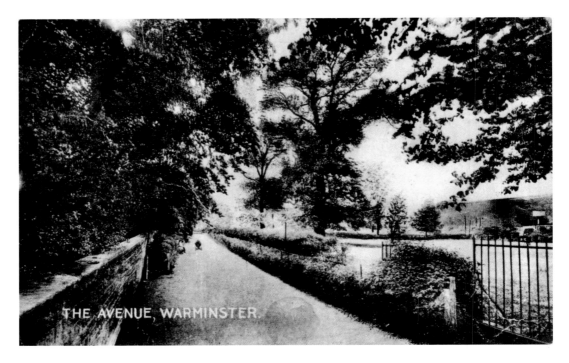

THE AVENUE, WARMINSTER.

The Avenue

The Avenue, which connects Portway and Station Road, is home to the Avenue Surgery and the Avenue Primary School. The surgery replaces the original town surgery in Portway. The Avenue Primary School started life in 1931 as the Avenue Senior School and later became the Avenue Secondary Modern. Some of its early pupils, living in villages around Warminster, were the lucky recipients of Education Authority-owned bicycles, provided to get them to and from school. The primary school was opened in 1968.

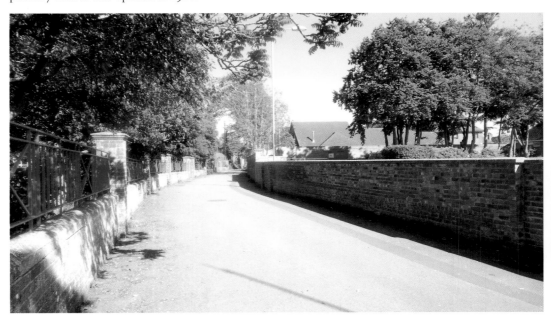

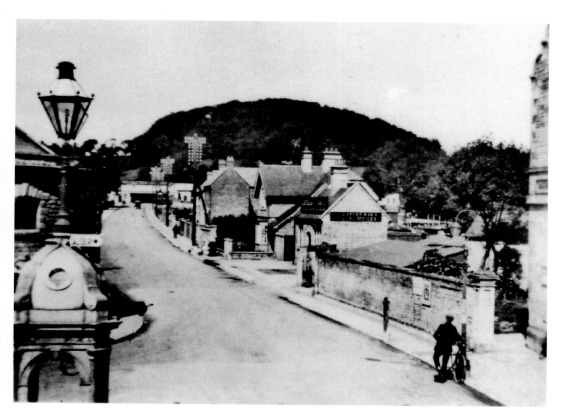

Station Road

This view along Station Road, dating from the 1920s and taken in the days of the steam trains, shows the all-important coal offices on the right. Dominating the background is Copheap Hill, which, like the famous neighbouring hillfort on Cley Hill, is surmounted by a Bronze Age barrow.

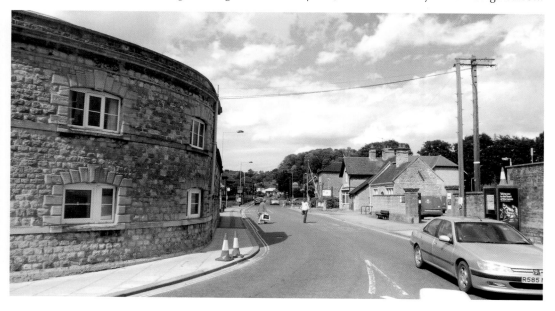

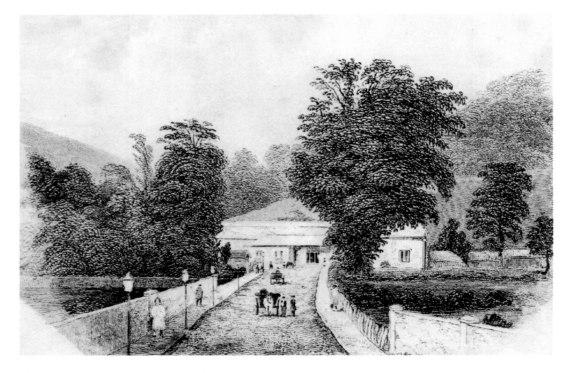

The Railway Station, Station Road

The coming of the railway usually improved the prosperity of the settlements it reached, but this seems not to have been the case with Warminster. Instead, the Victoria County History entry for the town claims that when it was opened by the Great Western Railway in 1851, linking Warminster with Salisbury by 1856, 'its coming marked the beginning, and was largely the cause, of a period of comparative depression. The great market declined almost to nothing, the retail trade suffered in consequence, and hardly any industry was carried on.' The station's canopied wooden buildings date from about 1930.

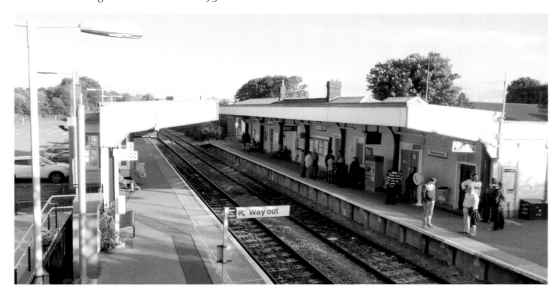

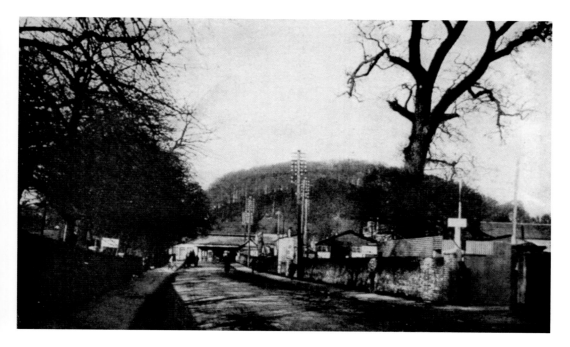

Station Road

In the background of the older image of Station Road looms Copheap. Station Road had a cattle market, laid out as part of a relief scheme providing employment for the unemployed in the early 1920s. In 1924 a factory was established in Station Road serving the needs of Warminster's well-established gloving tradition. By 1938 Dent Allcroft glover's were employing 130 workers at the site. Station Road also provided the location for Warminster's new police station and adjoining police houses, built between 1931 and 1932.

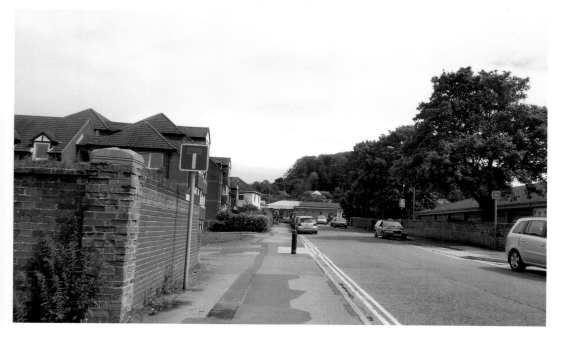

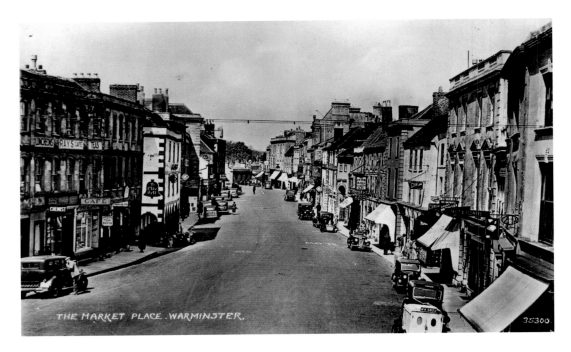

THE MARKET PLACE. WARMINSTER.

35300

The Olde Bell & The Anchor Hotel, Market Place

This photograph of the Market Place, taken around the middle of the twentieth century, shows several hostelries including, on opposite sides of the road, the Old(e) Bell Hotel and the Anchor Hotel. The Old Bell was a coaching inn with stables. For some years it hosted the annual Warminster Hospital Ball. Listed as a public house in 1899 and as a hotel a hundred years later, the Anchor is another long-lived Warminster inn. Both properties were renovated in 1998 and are still trading today.

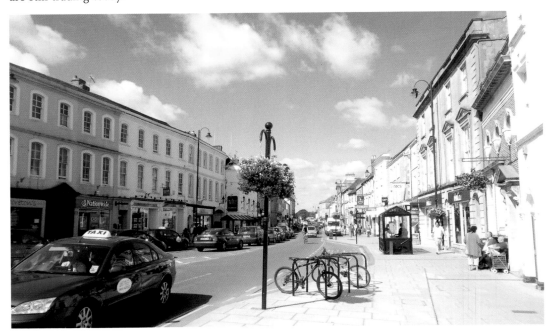

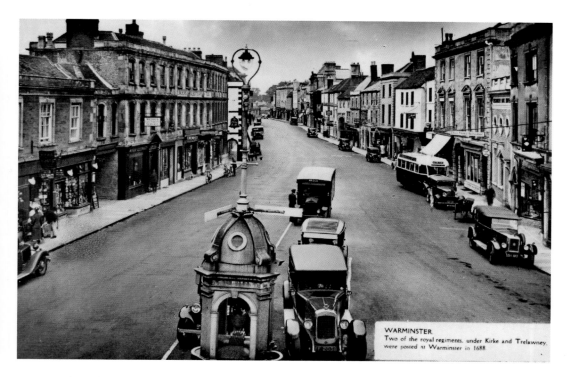

WARMINSTER.
Two of the royal regiments, under Kirke and Trelawney, were posted at Warminster in 1688.

Market Place

These views of Market Place from the post office/sorting office demonstrate how little Warminster's attractive town centre has changed over the last century. When the Pleasure Fair came to town – twice a year until the 1960s – this street was packed with stalls, amusements and people from the post office to the town hall.

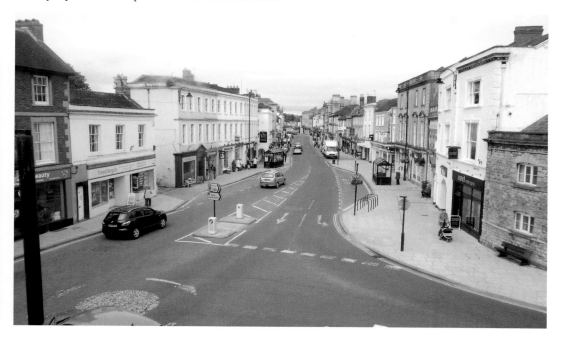

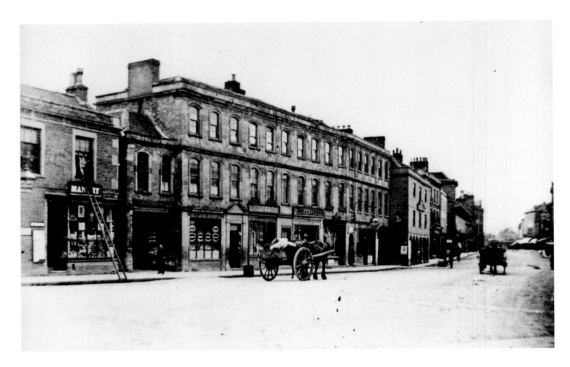

Market Place

Warminster's market dates back at least as far as the early thirteenth century. For many centuries the trade in corn was its principal concern, but its cattle and other livestock market was also of considerable local economic importance. By the early modern period it was regarded as the most important corn market in the whole West Country and received special mention in the writings of such luminaries as John Leland, John Aubrey and Celia Fiennes. The introduction of the railway brought Warminster into greater competition with neighbouring market towns such as Salisbury, Chippenham and Devizes.

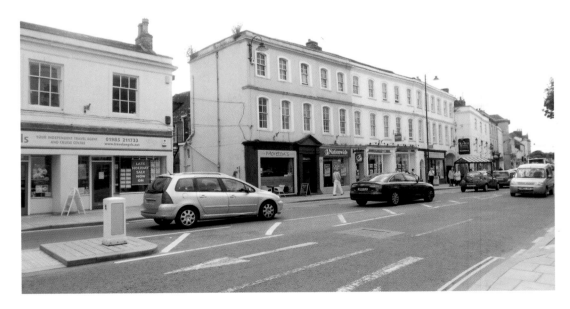

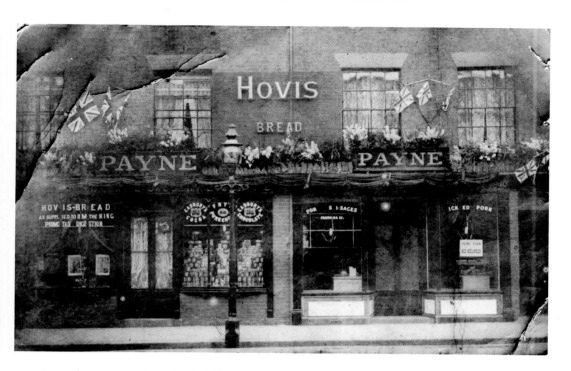

Payne's Grocery Shop, Market Place

The splendid shop shown in the older image here is Payne's grocery shop. This image is dated in the museum collection to around 1910; the Union Jack flags and floral decorations suggest it was taken in 1911, the year of George V's coronation. The shop advertises various products, including Fry's cocoa, Cadbury's chocolate, and Hovis bread by appointment to the King and 'promoting digestion'. Today the premises house a travel agency.

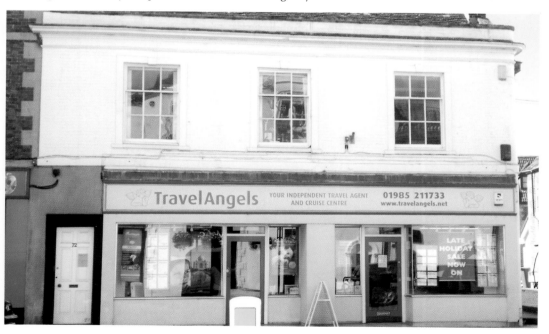

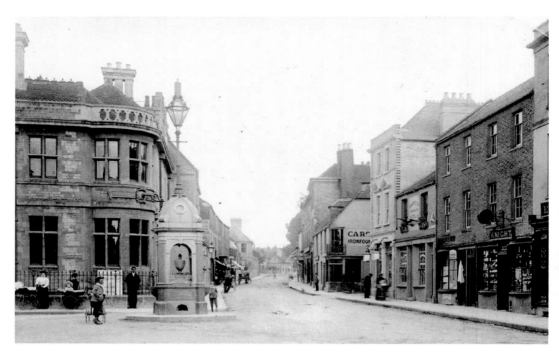

Post Office Junction

The fountain in the picture above was gifted to the town in 1892 in memory of Mrs Catherine Morgan. It was later moved to the Park, where it has remained ever since. Carson and Toone's Wiltshire Iron Foundry in Carson's Yard, East Street, was founded in 1816 and closed in 1909, at around the time the photograph was taken.

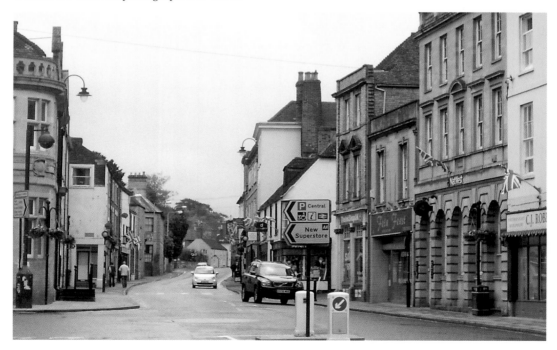

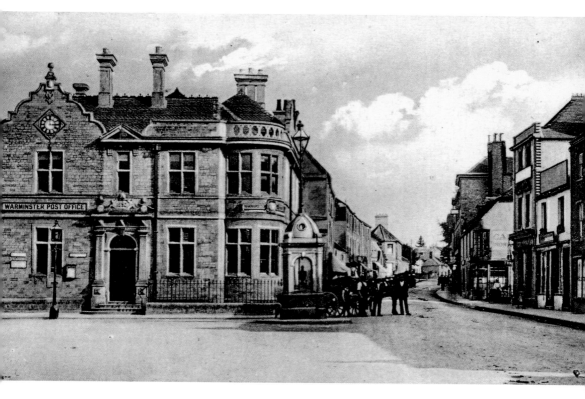

The Post Office, East Street
For ninety-two years, until 1995, Warminster's post office occupied these premises in the Market Place. In the early nineteenth century the post office was in George Street.

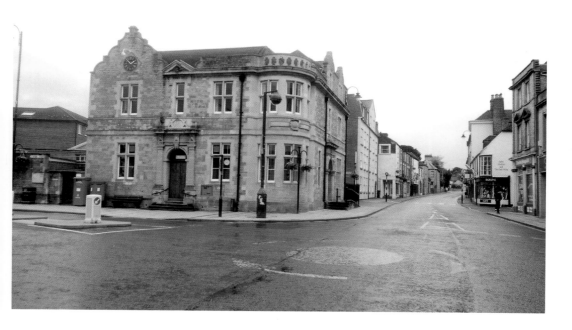

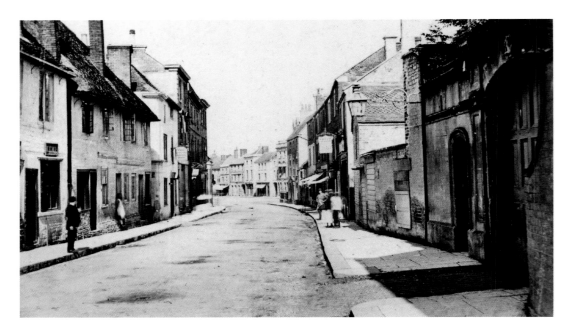

East Street

This photograph, looking along East Street, is thought to date from 1875. Two pub signs can be made out in the centre of the picture – the Swan Inn on the right and the Masons' Arms on the left. In 1898, the Masons' Arms had its own microbrewery. It no longer brews its own beer but still operates as a public house.

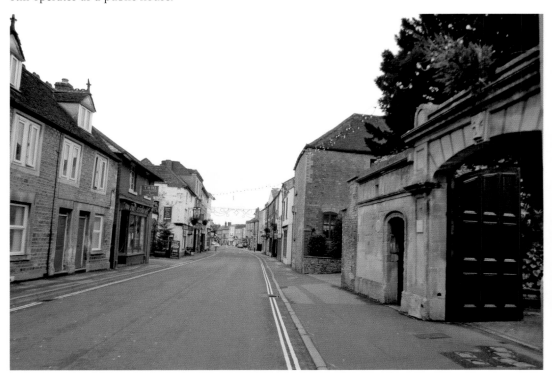

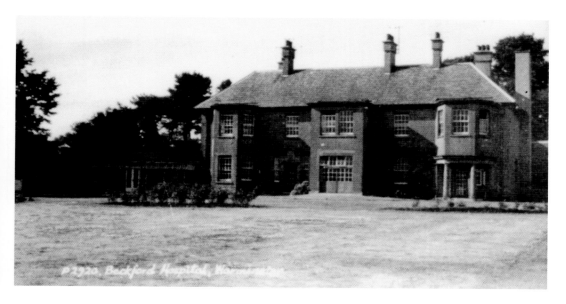

Beckford Hospital, Gipsy Lane

The Beckford Lodge Hospital was a U-shaped, two-storey house built in 1913. During the First World War it was used by the Red Cross as a convalescent home for injured soldiers, before it was donated in 1919 by its owners, the Pitt family, to Dorset County Council to serve as a hospital for up to thirty-four patients afflicted by tuberculosis. The hospital was opened by Lord Rivers of Cranborne Chase in 1920. Now known as the Beckford Centre, the old hospital is due to be demolished to make way for a modern eighty-bed nursing home with landscaped gardens and allotments.

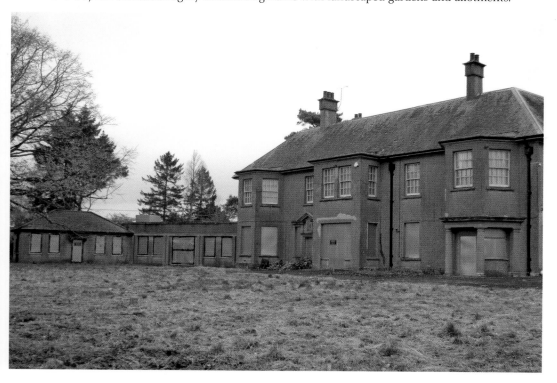

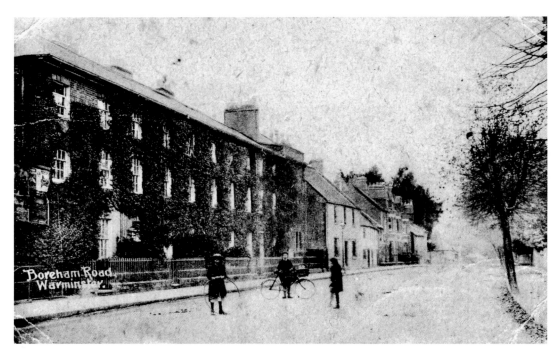

Boreham Road
Boreham Road was developed in the mid-nineteenth century with the building of middle-class suburban 'villas' and a new church – St John's – designed by the well-known Victorian architect G. E. Street.

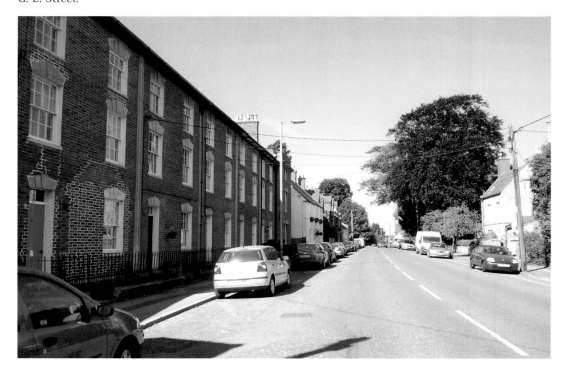

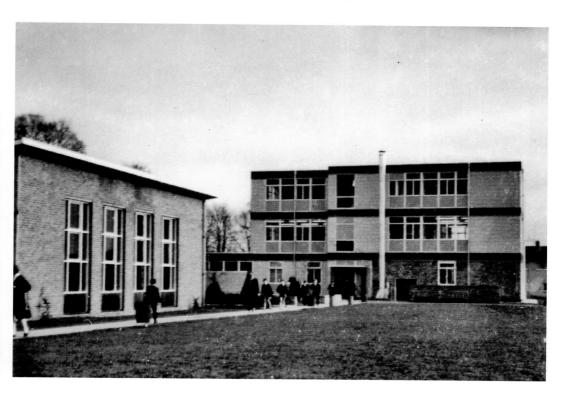

Kingdown School
Constructed on farmland in Woodcock, Kingdown School was built in 1960 to accommodate the growing number of secondary school children who had previously been provided for by the Avenue and Sanmbourne Schools. The school adopted a 'house' system for their pupils. Two of the houses were named after the principal rivers in the area, Wyle and Deverill, and two after local hills, Cley and Arn. In a recent OFSTED report the school was defined as 'outstanding'. Its inspirational slogan is 'Believe, Aspire, Achieve'.

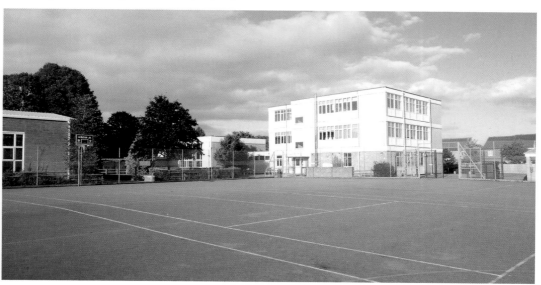

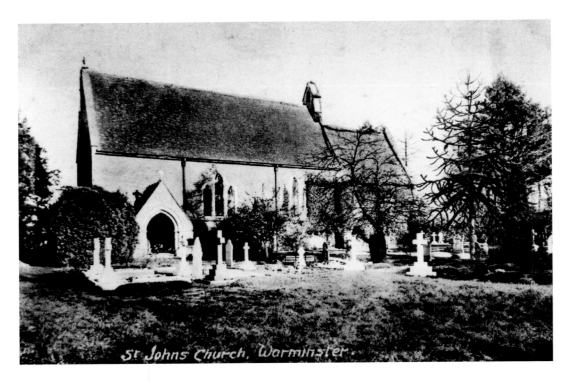

St Johns Church, Warminster.

St John's Church

St John's on Boreham Road is a relatively recent foundation, having been built in the 1860s due to the overcrowding of the parish church of St Denys. It is built in typical Victorian Gothick style. Its interior is illuminated by some striking turn of the century paintings of episodes from the scriptures, designed by C. E. Ponting.

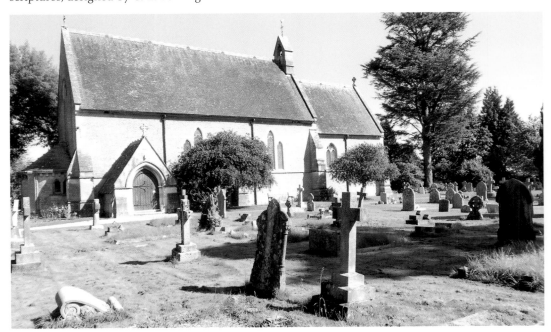

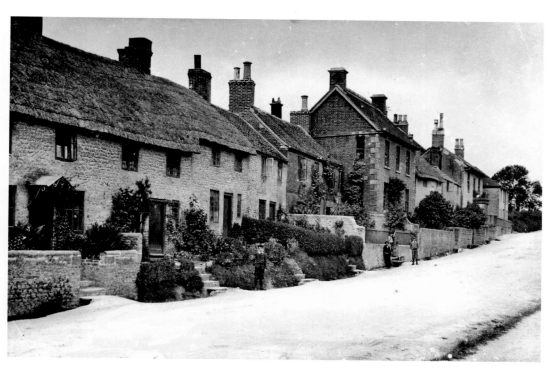

Boreham Hill

Thatched properties were once abundant in Warminster. Another feature that has also disappeared since the photograph above was taken is the open drainage ditch in front of each cottage.

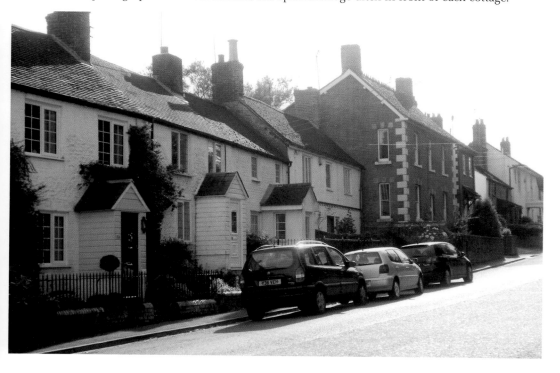

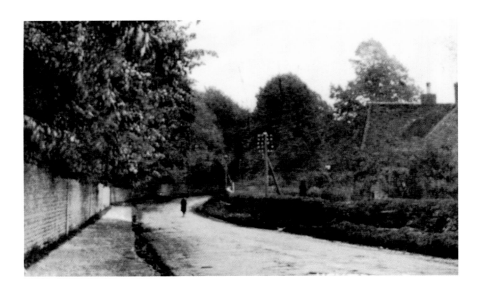

Heytesbury

Heytesbury is a very attractive village, formally regarded as a town, a couple of miles to the south of Warminster and set in beautiful countryside. Until the parliamentary reforms of 1832, from 1449 Heytesbury returned two Members of Parliament. The village was largely destroyed by a great fire in 1766, and by the start of the photographic age it had been reduced to little more than a single street of dwellings and occasional commercial premises.

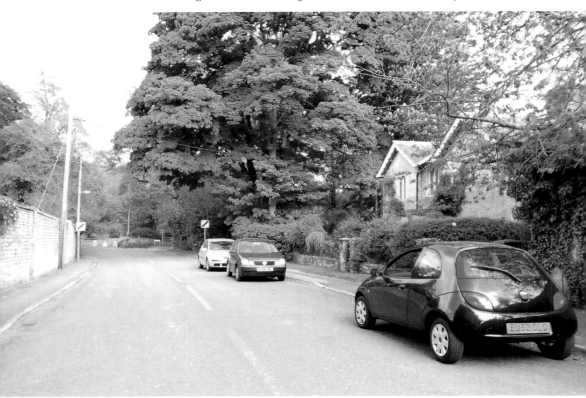

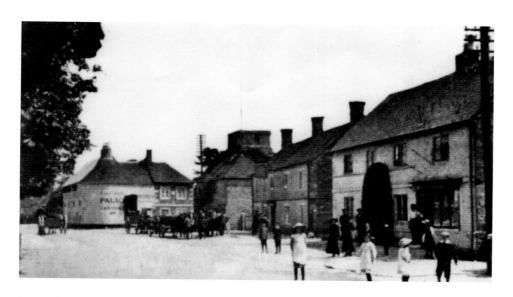

Heytesbury Church

In the photograph above, the massive Norman tower of Heytesbury's church can be seen. Dedicated to St Peter and St Paul, the church dates from the twelfth century and was restored under the guidance of William Butterfield in the 1860s. The important Wiltshire antiquarian and proto-archeologist, William Cunnington (1754–1810), is buried in Heytesbury churchyard.

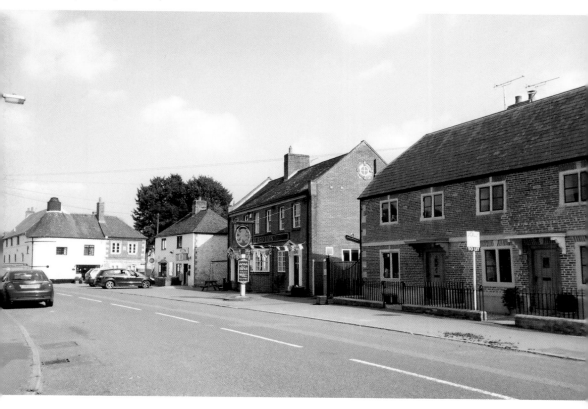

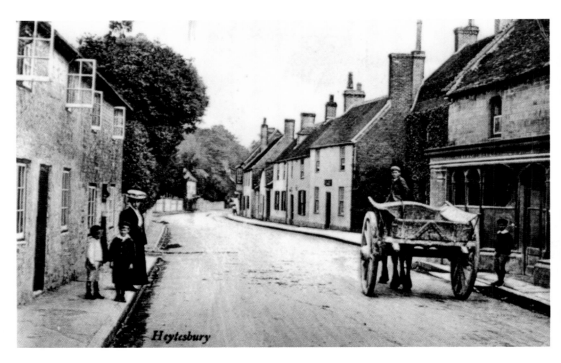

High Street, Heytesbury

Apart from the redesign of a former shop window on the building in the foreground, the houses on the right-hand side of the High Street in these pictures are little changed. The village's most famous inhabitant was the First World War soldier and poet Siegfried Sassoon, best known for *Memoirs of a Fox-Hunting Man*, the first volume of his fictional autobiography. He bought Heytesbury House in 1933 for £20,000, the house in which he went on to write the three volumes of his own autobiography.

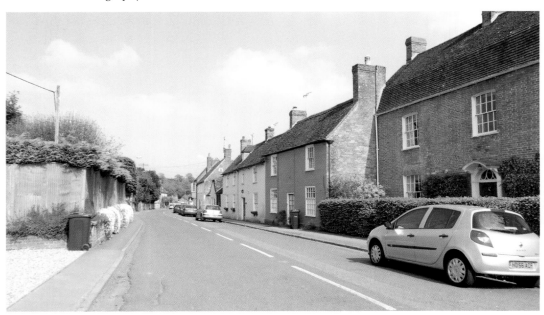

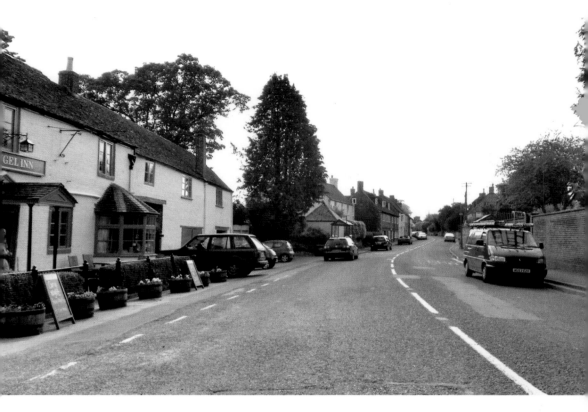

The Angel Inn, Heytesbury

The Angel Inn dates from the sixteenth century. It once served as a coaching inn and, according to local tradition, it was visited by the Pilgrim Fathers in 1620 *en route* to Plymouth and their historic journey in the *Mayflower*. The Angel continues to provide food, drink and accommodation for travellers to Heytesbury and Warminster.

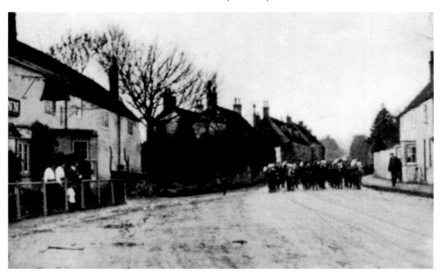

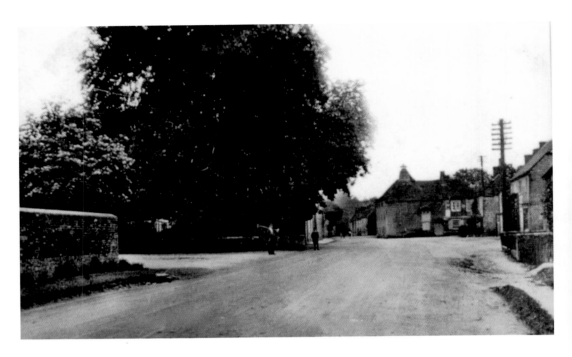

Heytesbury

The great chestnut tree has gone but in other respects this view along Heytesbury's main street is largely unchanged. Back in 1872 the village was still a reasonably bustling place, described by Marius Wilson in his *Imperial Gazetteer of England and Wales* as having 'a post office under Bath, a railway station, two chief inns, a church, an Independent chapel, a national school, and an endowed hospital.'

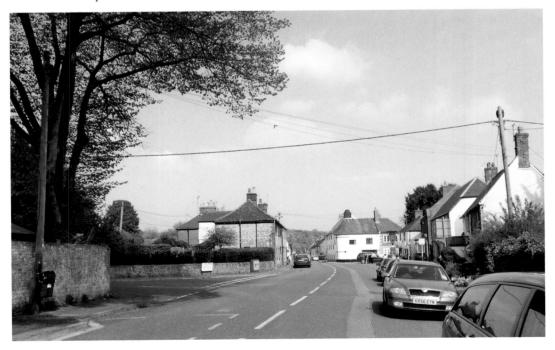

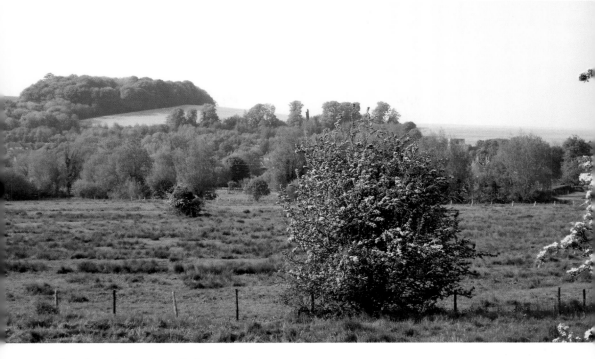

View from Heytesbury Railway Station
The village of Heytesbury once had its own railway station. Residents now either have to travel to Warminster or Salisbury before catching a train.

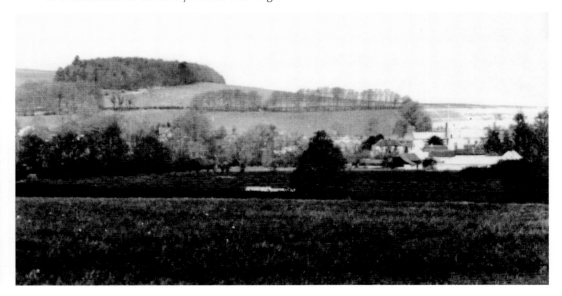

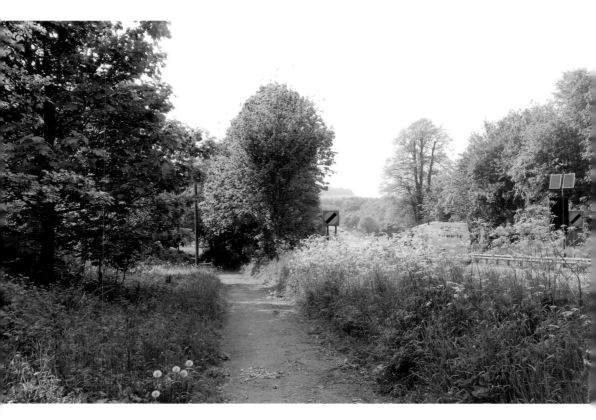

Knook Steps

The Knook Steps walk once provided a direct route from Heytesbury to the neighbouring hamlet of Knook, situated on the River Wyle. These days, however, it is dissected by the busy A36 and is most commonly associated with its Army base. Not far away, on the Downs to the north, and served by the same parish council as Heytesbury and Knook, is the famous village of Imber, deserted in modern times to serve as a military exercise area.

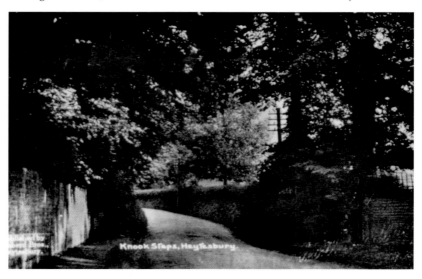

Knook Steps, Heytesbury.

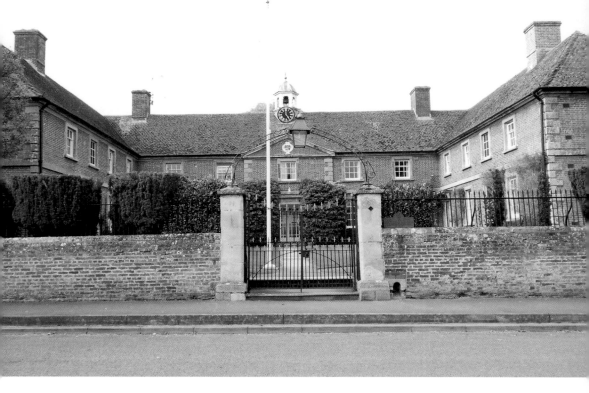

St John's Hospital, Heytesbury

In his *Imperial Gazetteer of England and Wales (1870–72)* John Marius Wilson wrote: 'The hospital was founded in 1470, by Lady Hungerford, for a chaplain, twelve poor men, and one poor woman; was rebuilt in 1769; forms three sides of a square, two stories high; and has an endowed income of £1,373.' Now a Grade II listed building, the hospital continues to serve as a charitable institution providing homes for the elderly.

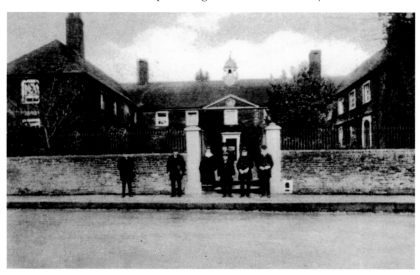

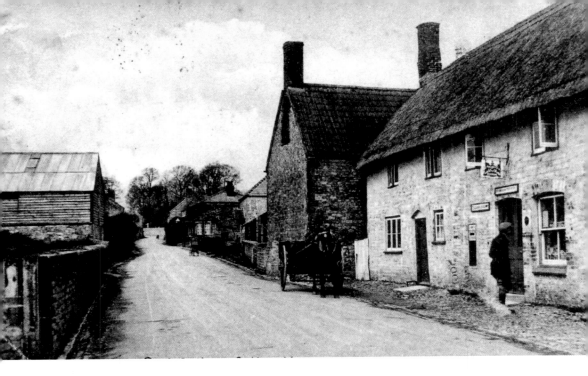

Sutton Veney Post Office

Although much of the main street of the village of Sutton Veney comprises buildings dating from the late nineteenth century, some earlier structures survive including a timber-framed building subsequently divided into a row of four cottages. Present appearances obscure the village's past reputation as a place of severe rural poverty and insanitary conditions.

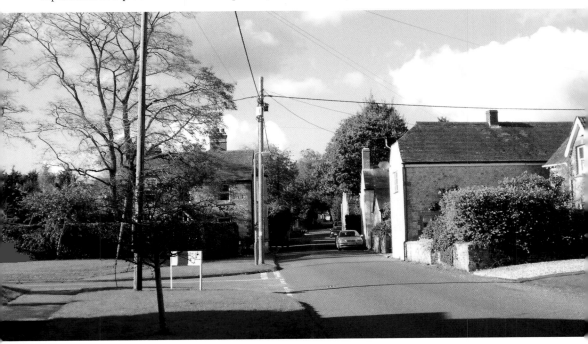

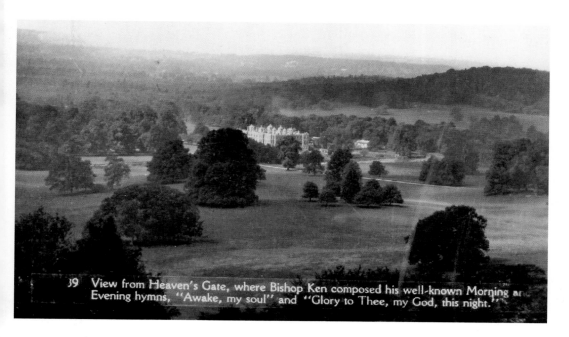

39 View from Heaven's Gate, where Bishop Ken composed his well-known Morning and Evening hymns, "Awake, my soul" and "Glory to Thee, my God, this night."

Heaven's Gate, Longleat House

A very popular local walk takes in Heaven's Gate on the ridge above Longleat on its south side. From Heaven's Gate there is a stunning view of the house in its beautiful setting. In 2001 a circle of twenty-two colossal standing stones carved from granite by Paul Norris was created at the behest of Alexander Thynn, Lord Bath, who commented at the time of their unveiling, 'Although the artist has deliberately left the meaning of the stones up to each individual to decide, one could say that they represent the ancient spirits of Longleat and the timeless Wessex landscape.'

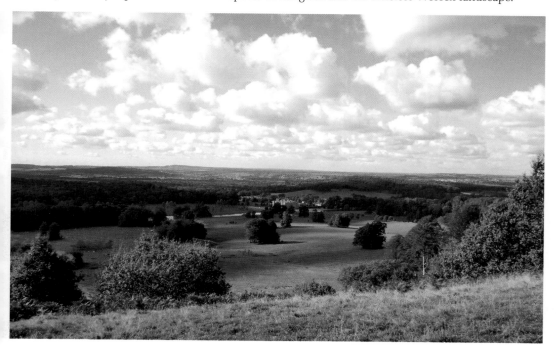

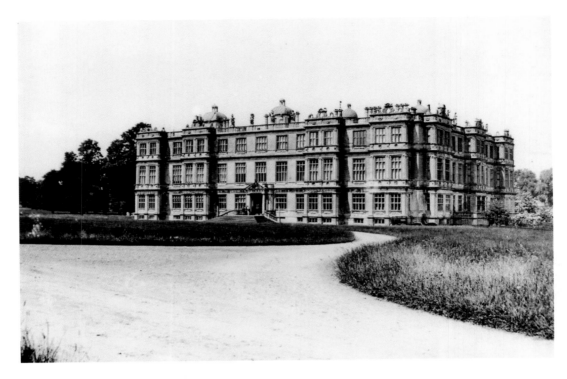

Longleat House

Warminster has long had a close relationship with its illustrious neighbour, Longleat House. Built on the site of a medieval priory, this Elizabethan mansion is renowned for its magnificent architecture. Its interior contains many treasures and its Capability Brown gardens are set alongside a wide range of theme park attractions and its famous 'safari park', the first of its kind in Europe. The Thynne/Thynn family, as the Marquesses of Bath, have endowed several institutions in Warminster, past and present, most notably Warminster School.

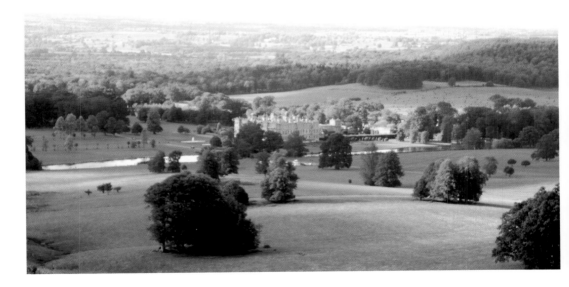

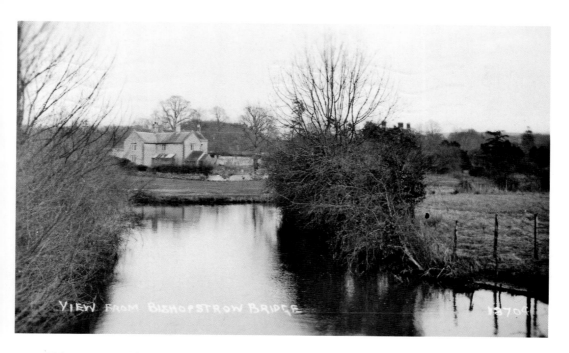

VIEW FROM BISHOPSTROW BRIDGE

Bishopstrow Bridge

The River Wyly at Bishopstrow, photographed here from Bishopstrow Bridge, turned the wheels of the manor's mill in the eleventh century when it was recorded in the Domesday Book in 1086. By the sixteenth century the mill was used for both grinding corn and fulling wool. In 1873 the existing three-storey brick building replaced the older mill following a disastrous fire. By the end of the nineteenth century, steam powered the mill in addition to water. The mill, now electrified, continued to be used in the twentieth century, thus maintaining a near thousand year old tradition.

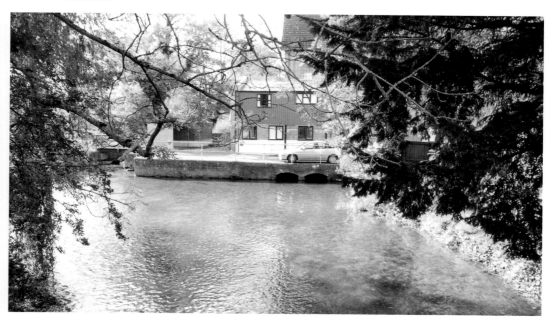

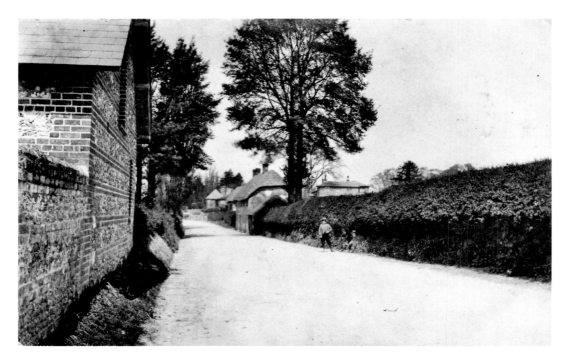

Bishopstrow

Bishopstrow's thatched roofs have gone but the terraces of early nineteenth-century cottages that dominate its main street survive. After a spell of engagement in aspects of the woollen cloth trade during the early stages of the Industrial Revolution, Bishopstrow reverted fully to agriculture before the dawn of the photographic age. These days it provides homes in a very desirable location for commuters to Warminster and elsewhere.

Acknowledgements

Andrew Pickering: text
Kathryn Dyer: picture research, photographs

The authors are very grateful to all those who have helped make this book possible through the loan of images and other materials, in particular: The Dewey Museum, Jean Colgrave, and Pat Andrews.

Bibliography

Books

Cunningham, M. E., *Bronze Age Barrows on Arn Hill, Warminster* (Wiltshire Archaeological and Natural History Society, 1912).

Field, J., A. Houghton, and D. Dodge, *Old Pictures of Warminster* (The Warminster Historic Society, Warminster, 1984).

Howell, D., *An Old Postcard Album of Warminster* (1985).

Howell, D., *Warminster – The Way We Were* (1988).

Howell, D., *Warminster in Old Photographs* (1989).

Howell, D., *Warminster 1899* (1992).

Lane, C. and P. White, *Warminster in the Twentieth Century* (The Warminster History Society, 1999).

Ries, J. and S. Dewey, *In Alien Heat: The Warminster Mystery Revisited* (2005).

Wilson, J. M., *The Imperial Gazetteer of England and Wales* (1870–1872).

Websites

www.visionofbritain.org.uk and www.dannyhowell.net